George Caleb Bingham

PROJECT SPONSORS

Missouri Center for the Book
Western Historical Manuscript Collection, University of
 Missouri–Columbia

᠂᠊᠊᠊᠊᠊

*The University of Missouri Press offers grateful acknowledgment
for generous contributions from the Thaw Charitable Trust and
the Friends of Art History, Santa Fe, New Mexico, in support of
the publication of this volume.*

MISSOURI HERITAGE READERS
General Editor, Rebecca B. Schroeder

Each Missouri Heritage Reader explores a particular aspect of
the state's rich cultural heritage. Focusing on people, places,
historical events, and the details of daily life, these books illus-
trate the ways in which people from all parts of the world
contributed to the development of the state and the region. The
books incorporate documentary and oral history, folklore, and
informal literature in a way that makes these resources accessi-
ble to all Missourians.

Intended primarily for adult new readers, these books will
also be invaluable to readers of all ages interested in the cultur-
al and social history of Missouri.

OTHER BOOKS IN THE SERIES

George Caleb Bingham

*Missouri's Famed Painter
and Forgotten Politician*

Paul C. Nagel

University of Missouri Press
Columbia and London

Copyright © 2005 by
The Curators of the University of Missouri
University of Missouri Press, Columbia, Missouri 65201
Printed and bound in the United States of America
All rights reserved
5 4 3 2 1 09 08 07 06 05

Library of Congress Cataloging-in-Publication Data

Nagel, Paul C.
 George Caleb Bingham : Missouri's famed painter and forgotten
politician / Paul C. Nagel.
 p. cm. — (Missouri heritage readers)
 Summary: "Paul Nagel's biography of nineteenth-century American
painter and statesman George Caleb Bingham assesses Bingham's artistic
achievements and his service as a political leader in Missouri during
Reconstruction. Illustrations include both well-known and rarely seen
works by Bingham"—Provided by publisher.
 Includes bibliographical references and index.
 ISBN 0-8262-1574-2 (alk. paper)
 1. Bingham, George Caleb, 1811–1879. 2. Painters—Missouri—
Biography. 3. Politicians—Missouri—Biography. I. Title. II. Series.
 ND237.B59N34 2005
 759.13—dc22 2004027682

♾™ This paper meets the requirements of the
American National Standard for Permanence of Paper
for Printed Library Materials, Z39.48, 1984.

Designer: D.S. Freeman
Typesetter: Foley Design
Printer and binder: Thomson-Shore, Inc.
Typeface: Palatino

To the memory of my great great grandfather,

JOHANN ADAM KLOECKNER
(1805-1886)

As a teacher, he brought his family from Bavaria to Boonville, Missouri, in time to see a young neighbor, George Caleb Bingham, find himself as an artist. Meanwhile, Adam Kloeckner established an academy in Boonville where the youth of central Missouri were instructed.

Contents

Color Illustrations

Acknowledgments

All who write about George Caleb Bingham must do so with the aid of the State Historical Society of Missouri in Columbia. This is mainly because the society possesses the letters Bingham sent to his close friend James S. Rollins. Studying this correspondence is the principal means of understanding the personality and career of Bingham. I thank the society for permitting me to read and quote from Bingham's correspondence with Rollins and also for allowing me to use the few surviving letters that Bingham wrote to other individuals.

While many individuals encouraged and helped as I prepared this biography, I am able to thank only a few of them here. I think first of my friend Thomas B. Hall III, M.D., who is a leader in the successful effort to restore and preserve Arrow Rock, Missouri, where Bingham was a resident. At my request, Dr. Hall took many photographs of scenes important in the Bingham story, illustrations that breathe life into these pages. For these I am deeply grateful to him, as I also am for his permission to reproduce Bingham's beautiful portrait of Sallie Hall Todd in this book.

Another invaluable contributor is Fred R. Kline of Kline Art Research Associates and the Fred R. Kline Gallery of Santa Fe, New Mexico. In 1999, Fred Kline discovered a canvas that, through his subsequent and meticulous research, has proved to be *Horse Thief*, the long-missing landscape by George Caleb Bingham. Thanks to the generosity of Mr. Kline, *Horse Thief* appears here for the first time as an illustration.

Biographies of great artists should have much of their achievement reproduced in color. The support of two benefactors made

beautiful illustrations possible in this book. I am deeply grateful to Eugene V. Thaw, chairman of the Thaw Charitable Trust. A very generous grant by that trust was crucial in enabling this book to show the reader the glory of Bingham's colors in his paintings. The second organization whose financial contribution brought color to these pages was the Friends of Art History, Santa Fe. I deeply appreciate the support of members of this group. A third and no less important source of help in paying for illustrations has been a grant from the Missouri Humanities Council, assistance made possible with support from the National Endowment for the Humanities. I thank the council and the endowment.

Now to return to Missouri and my thanks to individuals there who have been especially helpful to me. At the Jackson County Historical Society, Jim Giles and David Jackson were always there when I needed them, as was the Independence historian Brent Schondelmeyer. I'm grateful to Patsy Moss, an able Bingham scholar in the Kansas City area, for her encouragement. I found her research very helpful.

Many years ago, my appreciation of Bingham and his work was much enlarged by conversations with two leading curators of American art. These were Henry Adams, at that time the curator at the Nelson-Atkins Museum of Art in Kansas City, and Michael Edward Shapiro, who was then chief curator at the Saint Louis Art Museum. Each of these museums has been more than cooperative in the publication of this biography.

Finally, I must acclaim the memory of a friend, Charles van Ravenswaay, whose pathbreaking writings about Missouri's rich cultural heritage opened the eyes of numerous younger historians. I shall always be grateful for the day long past when Charles escorted me on visits to homes in Missouri where Bingham portraits and paintings were to be found.

More than a word of thanks is due Rebecca B. Schroeder, general editor of the Missouri Heritage Readers Series. She had suggested for some time that I write about Bingham. It has been a special pleasure to work with Beverly Jarrett, the University of Missouri Press's director and editor-in-chief, and her associate,

Sara Davis. They represent the admirable development in the press as I remember it from thirty years ago when I was a faculty member at the University of Missouri.

This makes an even dozen occasions when I have thanked Joan Peterson Nagel, my wife, for the indispensable ways in which she has joined in pushing a book of mine toward completion. But when I tell her that Bingham's story will be my final writing project, Joan appears skeptical—with good reason, perhaps?

Introduction

If you asked Missourians to name places that bring honor to their state, many would surely begin with the Truman Presidential Library in Independence, followed, perhaps, by the Gateway Arch in St. Louis, Mark Twain's Hannibal, and the Ozarks. A less obvious place should appear on these lists—New York's Metropolitan Museum of Art. In a gallery there is a famous work by Missouri's great painter George Caleb Bingham (1811-1879): *Fur Traders Descending the Missouri.* Of all the marvels of American art featured by the Metropolitan Museum, Bingham's river scene is the painting visitors most often ask to see.

George Bingham completed *Fur Traders Descending the Missouri* in 1845 while he lived in Arrow Rock, a village perched above the Missouri River in the central part of the state. This painting is the earliest of the many that would place him among America's—and the world's—great artists. But recognition was slow to come. For nearly forty years after his death, Bingham remained mostly forgotten. This seems astonishing since he had been more than a highly successful painter in his lifetime. He had also served Missouri as a political leader.

Although Bingham's artistic triumphs eventually came to be widely applauded, his career as a Missouri statesman is scarcely remembered. Such an omission calls for a new biography of Bingham, one that marks the breadth of his achievement. This book aims to portray the complete George Caleb Bingham: the artist, the politician, and the person.

Missourians have at last begun to award Bingham the acclaim he deserves. In 1976, he won tribute of a magnitude rarely matched by any artist in any state. That year the public discov-

ered that Bingham the painter had also been a master at sketching and that 112 of his marvelous drawings of mid-nineteenth-century Missourians had survived. This collection depicts many types of citizens, nearly all male—Bingham was shy about depicting women. He sketched ruffians, flatboatmen, farmers, and dignitaries—offering an authentic glimpse of Missouri men in the generation after Missouri attained statehood.

In 1975, the Mercantile Library of St. Louis, which owned the drawings, announced that it would have to sell the collection. The decision threatened to destroy a great cultural treasure by scattering the sketches among individual buyers. Determined to prevent such a catastrophe, a group led by Missouri's Governor Christopher S. Bond set out to raise enough money to purchase the drawings on behalf of the people of the state. The Mercantile Library agreed to sell the collection to the public for $1,800,000, the value set by the lowest of three appraisals. This impressive amount was promptly donated by citizens and institutions, with perhaps the most touching contribution coming from a campaign led by the schoolchildren of Missouri, and Bingham's sketches became the property of the people of Missouri. The collection is now in the care of the St. Louis Art Museum and Kansas City's Nelson-Atkins Museum of Art.

The campaign to save the sketches brought national attention, making Bingham's name and his work a topic of general conversation and leading to calls for a long-overdue national exhibit of Bingham paintings. Such a show was mounted in 1990 by the Saint Louis Art Museum and the National Gallery of Art in Washington, D.C. The exhibit contained thirty of Bingham's finest canvases, including the legendary *Fur Traders Descending the Missouri.* The exhibit's success was assured when Boatmen's Bancshares, Inc., of St. Louis consented to loan two of Bingham's most admired political paintings, *Stump Speaking* and *The Verdict of the People,* but on the condition that they be displayed only at the Saint Louis Art Museum (February to May 1990) and at the National Gallery in Washington, D.C. (July to September 1990). Art lovers from around the world made pilgrimages to these

locations for never before had Bingham's greatest work been gathered on display.

Other tributes to Bingham followed the exhibition. In 1990, the U.S. Postal Service issued a stamp commemorating *Fur Traders Descending the Missouri*. It was sold in the fifteen-cent denomination as a postal card. Several years later, two shows of Bingham's paintings were mounted in Missouri locations that had been important in his career. One opened in 1998 at the State Historical Society of Missouri located on the campus of the University of Missouri in Columbia. Not only did Bingham keep a studio in Columbia, but in his last years he also served as the first professor of art at the university. The other Missouri exhibit, which also took place in 1998, was in Arrow Rock, the village where the artist had grown up and where he lived and worked from 1837 to 1845. Bingham's residence in Arrow Rock is now a Missouri State Historic Site and a National Historic Landmark.

Since the exhibitions, tributes to Bingham's work have continued unabated. Most recently, in the autumn of 2004, the Minneapolis Institute of Arts featured a Bingham river painting in a major exhibit of works inspired by the Mississippi River. Soon afterward, the Nelson-Atkins Museum of Art in Kansas City opened an exhibit drawn from its collection and emphasizing the paintings of Bingham and Thomas Hart Benton.

One gallery tribute was, however, somewhat bittersweet in nature. During the economic depression of 2003, the Terra Museum of American Art in Chicago announced that it was obliged to close its doors. It gave fifty of its most important paintings to the Art Institute of Chicago. Of these, the museum announced that the finest were by three of America's greatest artists: John Singleton Copley from the eighteenth century; George Caleb Bingham from the nineteenth century; and Edward Hopper from the twentieth century. Bingham could not be in better company.

In addition to exhibitions, the rediscovery of Bingham has stirred up much thoughtful discussion relating to his work. Among the contributors are some of the leading scholars in the history of American art, including E. Maurice Bloch, John Francis

McDermott, Elizabeth Johns, Henry Adams, John Wilmerding, Michael Shapiro, Barbara Groseclose, and Nancy Rash. Rash's book, *The Painting and Politics of George Caleb Bingham,* published in 1991 by Yale University Press, is the only serious effort thus far to study Bingham's career in Missouri politics.

Bingham's most distinguished public service to Missouri took place in a time of great tragedy that began with the violence raised by the question of whether slavery should be allowed in Kansas. Bingham grew more involved during the Civil War and remained so in the bitter acrimony of Reconstruction thereafter. One of his most famous paintings, *Martial Law or Order No. 11,* was a passionate expression of outrage over wartime events in western Missouri. Bingham worked on versions of this canvas between 1865 and 1870. It was the last of his memorable creations as an artist.

Martial Law or Order No. 11 might well exemplify the life and nature of George Caleb Bingham. Just as the painting depicts tragedy, sorrow, and conflict, so the career of Bingham was often touched by controversy, pathos, and frustration. His life ranged from moments of high achievement to periods of distress and humiliation. Bingham's powerful paintings may tempt us to imagine that his life was as idyllic as most of the scenes he portrayed, but his surviving papers reveal a far more complicated story, one that this biography seeks to tell.

George Caleb Bingham

Chapter One

A Virginia Boy Goes West

George Caleb Bingham was more ambitious than most humans. He often fell woefully short of his aspirations—as when he yearned to be governor of Missouri, sought a seat in the United States Congress, or wished for diplomatic posts abroad. Even his most ardent desire had to wait almost fifty years after his death for fulfillment—acclaim as one of America's greatest painters. An achievement he cherished, however, came to Bingham through no effort on his part. This was his birth as a Virginian. Near the end of his life, when he was disgusted by the way the Missouri legislature treated him, Bingham liked to talk of the land of his birth, saying that Missouri was merely his adopted state.

But if Bingham thought that the location of birth could make a person a Virginian by nature, he was mistaken. Authentic Virginians enjoy tracing their lineage back to the seventeenth century when their ancestors set foot at places such as Jamestown. Bingham's forebears waited until after the American Revolution to enter Virginia's Shenandoah Valley, arriving from New England and Pennsylvania. Their ancestors had originated in Germany and England. For their part, George's parents did not linger long in Virginia before heading west.

Nowadays, Virginia assures everyone that the great artist was a son of the "Old Dominion." Motorists who drive along State Highway 256 through the Shenandoah Valley's Augusta County are informed by a handsome historical marker that "George Caleb

Bingham, a renowned American genre painter of the 19th century, was born in a frame house just north of here on 20 March 1811." The marker acknowledges that Bingham moved to Missouri in 1819, where he "specialized in paintings of the American West" before his death in Kansas City in 1879. The marker gives no hint that Bingham was far more than a distinguished artist.

It was, of course, genius with paints and pencil that brought Bingham enduring fame. Even before young George and his family left for Missouri, his parents had recognized his talent and had encouraged him to draw, using even the sides of barns and fence posts. Possibly this was because the future artist's father, Henry Vest Bingham, himself had a flair for sketching. Henry was the son of George Bingham, a planter and Methodist preacher, who had served in the Revolutionary army before moving from New England to the eastern slope of Virginia's Blue Ridge Mountains. There, in 1782, he married Louisa Vest. A year later Henry Bingham, their first son and the future father of the Missouri artist, was born.

At age twenty-one, Henry assumed the management of the Reverend George Bingham's property, which included overseeing the work of slaves. In 1807, a severe drought forced the Binghams to haul their grain harvest west into the Shenandoah Valley, where there had been enough rain to keep mill streams flowing. When young Henry Bingham was sent on this errand, he chose to do business at a mill located near Port Republic owned by Matthias Amend, one of many settlers of German ancestry who had moved from Pennsylvania into the Virginia valley. As he watched his load of wheat being ground, Henry listened as the miller told his story.

Matthias Amend had been a soldier throughout the American Revolution, serving beside John Bushong, an older neighbor who was a lover of books. After the war, Matthias married Bushong's daughter Elizabeth, who soon presented him with a son and a daughter. Unfortunately, Elizabeth and their son died just as Matthias was preparing to move his family to Virginia's Augusta County, where he had purchased land along the South River

intending to build a sawmill and a gristmill. Despite his loss, Amend kept to his plan and moved with his daughter to Virginia. The girl had been christened Maria Christina, but she was always called Mary.

Henry Bingham turned his attention to Mary Amend, who was then twenty years old, just four years younger than he, and a very attractive young woman. Beyond her charms were the bookish ways she may have inherited from her grandfather, John Bushong. Bingham learned that as a child Mary had spent her weekdays away from home attending one of the few schools in that part of Virginia. She had returned to the mill on weekends to share what she had learned with her father, who had no formal education. That experience would prove helpful in Mary's later career as a Missouri school mistress.

Bingham family lore holds that Mary and Henry fell in love even before the grinding of Bingham's grain had been completed. The two were married a year later, on September 8, 1808, when Henry returned to the Amend mill. The date proved a lucky day for the couple. To prevent his daughter and her husband from joining America's move westward, Matthias Amend gave his mill and farm to his new son-in-law with the stipulation that the old man would always have a home with the Binghams. It was a fine gift. Many years later, when George Caleb Bingham returned to visit the neighborhood where he was born, he found the revolving wheels of his grandfather's mill still operating and as handsome as the day his talented grandfather had created them.

When it came to producing children, Mary and Henry Bingham thrived. Six babies arrived between 1809 and 1818. The second was George Caleb Bingham, born on March 20, 1811. With Matthias's help, Henry Bingham also prospered in the milling business, despite difficulties brought by the War of 1812. When the war ended, Henry was so confident of good times ahead that when a friend asked for financial backing, Bingham readily guaranteed a loan: he pledged the milling and farming property, 1,180 acres in all, that old Matthias Amend had given to him.

Soon afterward, happy days in Virginia abruptly ended for

the Binghams. In 1818, Henry's friend died while still deeply in debt; this meant that most of the Bingham property and slaves had to be surrendered to pay the deceased's obligations. What remained was a small amount of cash, bits of furniture, a few fine horses, and several slaves. With these remnants of their wealth, Henry and Mary Bingham, along with their children and grandfather Matthias, set out to begin a new life.

One of the slaves sold by the Binghams was named Tom. He was still living in the neighborhood when a grown George Caleb Bingham visited the scene of his childhood in the Shenandoah Valley. As George told the story, he had remembered the old slave and sought his help as an escort around the community. First, the two men looked at the still-visible sketches George had made twenty-five years earlier on the walls of the family mill, and then, as George remembered, Tom looked up to heaven and called down blessings upon the future career of Bingham the artist. At that time, as it happened, George was feeling discouraged, and the words of the old slave were very welcome as he reported to his mother, "I felt that if the prayers of any man could avail for me, his would."

George was scarcely seven years old when his parents lost their property in Virginia, but he would always remember vividly the courage they displayed as they faced packing up and moving to the Missouri frontier. To complicate matters at the time, George's mother was pregnant with her sixth child. George remembered his father as "a fine specimen of vigorous manhood, measuring six feet in height and weighing over a hundred and eighty pounds" and "a constant reader" who had amassed much historical information, despite the limits of a primitive education. Actually, Henry Bingham was physically frail and astonishingly unlucky in most of what he undertook. He died when George was twelve.

Accepting the fact that his family had to join the migration westward, Henry Bingham decided to look before they leaped. He had heard much gossip about many locations along the American frontier. Particularly enticing were stories of places

beyond Kentucky that were called Indiana and Illinois, as well as a territory across the Mississippi River known as Missouri, reportedly perfect settings for a family needing to begin life anew. Consequently, in the autumn of 1818 young George and his brothers and sisters watched their father set out to see the American West for himself and choose a new home for his family.

When he returned, Henry Bingham was enthusiastic about what he had found. He amused his children with stories of his trip, some of which George never forgot. Most memorable was his father's description of being invited by a Kentucky magistrate to stay for dinner, which Henry discovered was to be eaten in a rude kitchen. There he sat down to dine surrounded by hogs and dogs. According to Henry, his host decided that since there was a guest in the house, just this once the animals should be put outside. One hound, however, refused to obey and squirmed under the magistrate's chair in order to grab a crust from the floor. When one of the children tried to pull the dog away, both chair and magistrate came down in a mighty crash.

But it was not the hospitable magistrate's Kentucky that Henry selected as the new residence for his family. Instead, his search finally took him across the Mississippi River into the Missouri Territory. There Bingham ignored the city of St. Louis with its strong French traditions, choosing to travel up the Missouri River to the Boonslick country, halfway across the territory, to land that marked the dividing point between forest and prairie. The area had been favored by many settlers from Virginia and roughly included the present-day counties of Howard, Saline, Chariton, and Cooper. Henry Bingham was drawn to a village named Franklin, then standing on the very edge of America's westward settlement. Founded in 1816, the town had so thrived by 1818 as to have a public land office and was second in size and importance to St. Louis. There were about fifteen hundred inhabitants, many of them slaves since human bondage was permitted in the territory. Henry listened as citizens talked enthusiastically about the imminent arrival of the recently invented steamboats that might be powerful enough to push against the

awesome Missouri River current. The first steamer, the *Independence,* reached Franklin in 1819. In 1821, the town became a departure point for the rugged Sante Fe Trail whose opening would lead to commerce with the Southwest and Mexico.

The prospects of the area captivated Henry, who hastened back to Virginia to gather his family for a move to Franklin. There is no record of how the Bingham family and their slaves managed the arduous journey. If they took the route of many immigrants, they struggled overland to the Ohio River, where they loaded their possessions on a flatboat. From there they floated downstream to join the Mississippi River, then turned north toward St. Louis and the mouth of the Missouri River. There, the flatboat men, whom George would someday immortalize in some of his greatest paintings, had to strain to keep the boat moving upriver until the Binghams "landed" at their new home in Franklin.

This great adventure for George, his parents, his five brothers and sisters, his grandfather, and seven slaves took place in the summer of 1819, soon after the U.S. Congress had begun its heated debate over the admission of Missouri to the Union. Not until two years later was the Missouri Compromise established and the state officially admitted with no restriction on slavery. By that time the Bingham family was comfortably settled, having lost little during the hazardous journey from Virginia except for several thoroughbred horses that had fallen victim to the equine "immigrant" disease, as settlers called it.

Henry Bingham immediately entered into life in Franklin. As frontier towns went, it was progressive, possessing a library, a racetrack, an agricultural society, a patrol for supervising slaves, and the first newspaper west of St. Louis. Franklin citizens claimed for their town the title "Metropolis of the West." Properly inspired, Henry Bingham sought a leader's role in the community—requiring that he go into debt.

Borrowing heavily, Bingham opened an inn, calling it the Square and Compass. When that investment seemed to thrive, he started a factory to manufacture tobacco products, particularly cigars. Henry went across the river into Saline County and

purchased 120 acres of public land on which to grow tobacco. His enterprise must have favorably impressed the citizens of Franklin. They quickly chose him as a justice of the peace and as chairman of a committee to improve community health— which, today, seems a bizarre assignment for a producer of cigars. Then, in 1822, the community elected Henry to a seat on the Howard County Court, the body which oversaw such important administrative matters as opening and maintaining highways.

A problem for the public greater than the roads at that time was the dangerous Missouri River. It brought two tragedies to the Bingham family, probably caused by their decision to own property on both sides of the river—residing in Franklin and operating a farm in Saline County. Consequently, family members—particularly Grandfather Matthias Amend—frequently made hazardous crossings of a river with, said Henry Bingham, "the strongest and most turbulent current in the world." Matthias, of course, had no bridge to use and had to rely on boat or ferry. Whatever method he employed eventually failed him, and the river claimed the old gentleman's life. In 1831, tragedy struck again. Despite his awe-inspiring name, Isaac Newton Bingham, one of George's brothers, became the second family member to drown in the Missouri River.

But the river was not content simply to carry off humans. Much of Franklin was built on the river's edge, and not long after the Bingham family arrived the annual floods began to eat away the town. Soon, Franklin literally tumbled into the Missouri River. Her citizens paid the price for failing to heed a folksy warning by river veterans that the Missouri "holds a mortgage on all property along her banks." By 1823, the government of Howard County had prudently moved its seat from Franklin to high ground where the village of Fayette already stood. A few persistent Franklin residents clambered two and a half miles up the hillside to establish New Franklin in 1829, leaving Old Franklin little more than a ghostly legend.

Henry Bingham did not live to see these events. On December 26, 1823, he died of malaria at age thirty-eight, bringing about a

curious reversal of the circumstances that had forced the Binghams to leave Virginia. Henry had died before there was time to repay the large debts incurred when he opened his inn and his factory, and he apparently had been imprudent in choosing his associates in the cigar business, who took the opportunity to defraud Henry's widow of her interest in it. As a result, Mary Bingham had to surrender the Square and Compass to pay her husband's debt.

Mary had little choice but to take George and his siblings across the river to live on the Bingham farm in Saline County. Fortunately for Mary, this property had escaped her late husband's creditors, perhaps because the federal government dallied in approving his purchase of the acreage. Not until November 10, 1825, did President John Quincy Adams sign the document that confirmed the property's title to "the Heirs of Henry V. Bingham dec'd."

By then, with her husband and her father dead, Mary Bingham was all but alone in rearing her brood of children. Near her Saline County farm, however, Mary did have the comforting presence of Henry Bingham's brother John and his family, as well as a cousin, Wyatt Bingham. These relatives had heeded Henry's descriptions of the splendid opportunities in the Boonslick country and settled in the area shortly before he died.

Unlike his brother Henry, John Bingham prospered. He became a generous benefactor of the town of Arrow Rock, the village near Mary Bingham's farm. It was in Arrow Rock with its spectacular view of the river valley that George Caleb Bingham chose to live during his early career as a painter. In George's choice of an artist's calling, his Uncle John had sought to discourage him. John Bingham saw no fruitful place in frontier Missouri for anyone who dabbled with colors and brushes. George might have heeded this advice, had it not been for his mother. More sophisticated than most of her neighbors, Mary Bingham supported her son when, as a lad, he "wasted time" in painting and sketching. Her backing would prove crucial when George Caleb Bingham was old enough to consider what to do with his life.

Chapter Two

Learning to Paint

W hile George Caleb Bingham's career has several baffling sides, the most intriguing aspect leaves us wondering how he could have become a successful painter, let alone a world-famous one. His formative years were spent on the edge of the Missouri frontier, for a brief time in the village of Franklin and thereafter on a farm in the near-wilderness of Saline County. How could a great artist emerge from such cultural deprivation? Another tantalizing question is how Bingham found time to paint many splendid canvases while engaged in other interests. His love of art had to compete with his passionate involvement in political affairs, as well as with his zest for business and moneymaking and his work as an amateur attorney. While the world acclaims Bingham's achievement as a painter, it tends to overlook how his many other interests made his triumph as an artist something of a miracle.

Nothing is more astonishing in Bingham's story than how his enthusiasm for painting was ignited at the age of nine as he grew up in the frontier wilderness. Had the youthful George's father not become the proprietor of an inn, George might well have missed a crucial inspiration. One of the inn's guests in 1820 was an artist already in the early fame of a career that would mark him as perhaps the finest American portrait painter of the first half of the nineteenth century. This most extraordinary visitor in frontier Missouri was Chester Harding (1792-1866). Thanks to the perfect timing of his stay in Franklin, Harding had a profound

influence on George Caleb Bingham, this in spite of having only two comparatively brief encounters with him.

Like Bingham, Harding had liked to sketch and paint on the sides of barns during his youth. His earliest skills, just as Bingham's would be, were as a cabinetmaker. And Harding himself had been inspired to paint by watching an itinerant artist— the same inspiration he would provide for a youthful Bingham.

When Harding's early efforts at painting, particularly portraits, won praise, he went in search of willing subjects and of other artists from whom he might learn. In 1818, his travels took him to Kentucky, where he studied with Matthew Jouett. After listening to Jouett talk about Kentucky's great pathfinder, Daniel Boone, and learning that Boone was then living in Missouri, Harding set out in 1820 to locate the hero and paint his portrait. He found Boone in St. Charles County, ill and staying in a cabin behind the home of his daughter Jemima. Harding hurriedly sketched the feeble old man and then headed up the Missouri River to Franklin, by then the residence of the Bingham family. There he intended to finish his painting of Boone while coaxing other residents who could pay to sit for him.

After he established a makeshift studio in one of the rooms in Henry Bingham's newly opened inn, Chester Harding found he would have a helper. It was nine-year-old George, whose parents had not forgotten the enthusiasm he had shown for sketching on fences and barns back in Virginia. Henry Bingham apparently was quick to see what a wonderful opportunity Harding's visit offered for young George. The impromptu, and unlikely, art school proved highly successful.

Like almost everything else in George Caleb Bingham's early years, his association with Chester Harding has been blurred by legend and by the unreliable memory of later generations. One writer even took the word of a Bingham descendant that it was not Harding but the great American artist Gilbert Stuart, famed especially as the painter of George Washington, who came to Franklin to train the child Bingham. What is known about George Caleb Bingham's early years relies upon his own

letters, a few of which have survived.

Fortunately, a letter written by Bingham in 1872 was recently found that provides assurance about the influence of Harding on his career. Bingham recalled the memorable summer of 1820 at the family inn, when his father had instructed him to be helpful to Harding. The assignment required that he remain beside the artist, allowing him to observe for the first time the sort of miracle on paper and canvas that a talented artist could produce. Writing almost fifty years later, Bingham recalled: "The wonder and delight with which his work filled my mind impressed them indelibly upon my . . . memory."

Under George's watchful eye, Harding completed his portrait of Daniel Boone and perhaps made a copy, while he also painted the likenesses of prosperous Franklin residents. He then gave George some brushes and paints before returning to Boston. Ten years later, Harding again visited mid-Missouri, at which time he and the still-youthful Bingham had a fruitful reunion.

But that second encounter occurred well after the Bingham family's tribulations in Missouri. While the story of the Binghams grows vague for a time after the death of Henry in 1823, it is not so obscure as to hide the courage and resourcefulness of Henry's widow, Mary Amend Bingham. Henry's debts had left George's mother not quite penniless. She possessed a bit of money along with the farm near Arrow Rock, the seven slaves the family had brought from Virginia, and seven children. Just as significant, especially in the development of her son George, Mary also owned a small but well-chosen collection of books, drawn largely from the classics. Throughout his life, George Caleb Bingham exhibited a remarkable knowledge of serious literature, ancient and modern, which he credited to his mother's encouragement.

George's mother also had the ability and desire to teach more youngsters than just her own sizeable brood. First in Franklin and then across the river near Arrow Rock, Mary operated a school meant particularly for girls, although she admitted some boys. The Widow Bingham's academy for young ladies was deemed a valuable adornment on the Missouri frontier. At the

time it opened, the school was acclaimed as the first "female seminary" west of the Mississippi River.

Mary chose not to do all the instruction by herself. Perhaps with an eye to the talent of her son George, she secured an associate, Mattie Wood, whose main contribution was to teach art to the pupils. Again, according to family lore, Mattie Wood picked up where Chester Harding had left off with George's early training, but the young man did not have the luxury of spending all of his time with books and paints. He was both janitor and handyman for his mother's school. There must have been plenty to occupy him since the academy had taken over a forsaken log building that had briefly served as a church.

As a pioneer left early in widowhood, Mary went on to educate her children, her grandchildren, and others in the community, while cutting a farm out of the wilderness and wresting a profit from it. During her career, Mary seems to have remained a southerner at heart, continuing to use slaves on her farm. At the time of her death, she owned four slaves. One of them was "Aunt Lucy," who had accompanied the Binghams when they emigrated from Virginia to Missouri. George bought three of the slaves from his mother's estate, but he freed them before the Civil War.

George never lost his appreciation and admiration for his mother. A profound sense of obligation toward her filled his letters and reminiscences. As he roamed the eastern states in the 1840s seeking professional profit, he wrote devotedly and often to Mary, calling her his anchor. When she died at age sixty-four in May 1851, George was in New York City exhibiting his work and also doing some painting. He hastened back to Missouri to sit beside her grave, which can be found today in the Arrow Rock cemetery. While the inscription on her stone is all but obliterated, visitors can read a plaque the Daughters of the American Revolution later placed at Mary's grave. Few women of the western frontier are more deserving of such a tribute than Mary Amend Bingham.

Another family member, however, was less helpful to George.

After Mary moved her children across the river to the Arrow Rock neighborhood, she soon came to rely upon her brother-in-law's advice and help with both her farm and her school. When John Bingham put Mary's children to work at farming, however, he faced a rude surprise—his nephew George expected to be treated differently from his brothers and sisters. The uncle could not dissent when part of George's time was assigned to keeping the school tidy and continuing in lessons in art from Mattie Wood, but John made no effort to hide his disgust when he found George sitting under a shade tree sketching instead of toiling in the field. Consequently, George's mother heard much stern talk from her brother-in-law, who thought there was no future in drawing and that it was a disgrace to see a sturdy lad lounging around with a pencil and pad of paper.

Much as Mary wished to encourage her son's talent, she could hardly argue with John's dire predictions of George's future uselessness. Then she remembered how Chester Harding had talked of getting his own start as a painter by working in a cabinetmaker's shop. Since her crops and livestock apparently would prosper without George's help, Mary determined that the best way to prepare her gifted son for life was to apprentice him to a cabinetmaker.

So, at age sixteen, George went to work, first with a carpenter in Arrow Rock. Then he was sent to Boonville, a more sophisticated town and the seat of Cooper County, located a short distance down the Missouri River from Arrow Rock. Here George learned more than he bargained for. He had the good fortune to be apprenticed to Justinian Williams, a Methodist preacher who was also a talented cabinetmaker. In young Bingham's day, a cabinetmaker or carpenter had to be an artist to succeed. All furniture still had to be designed and created "by hand." There was no mass production of chairs, tables, church pews, judges' benches, and the like. Cabinetmaking was a profitable outlet for anyone with an artistic bent.

While George was in Boonville, the complex nature of his emerging personality became noticeable. It must have been evi-

dent to his friends that the youthful Bingham was by no means dedicated to seeking an artist's life. Boonville offered George a number of distractions, among them his chats in the shop with his mentor, the Reverend Williams. The two talked often about religious matters, which led the younger man to spend much of his spare time consulting Holy Scripture. Soon, George was serving as a preacher before local congregations, who were usually desperate to find pastors. All his life, George would be known as "quite a talker" with religion continuing to be one of his favorite subjects. As an adult, he took pride in holding his own in disputes with theologians.

But it was not religious discourse alone that appealed to George. Like most frontier communities, Boonville had more than its share of would-be attorneys. It was comparatively easy at that time for an individual to be admitted to the bar, and George found this profession alluring. His fondness for debate and the good vocabulary his mother's training had instilled were assets that would have served him well had he become a lawyer instead of an artist. They later proved invaluable in his political career—whether he was speaking on the floor of the legislature or campaigning on a courthouse lawn. His capacity as "a big talker" also helped George prosper later when he acted as his own agent while traveling around the country selling prints made from etchings of his paintings.

Just as George was struggling to find a career out of his varied interests, Chester Harding made his timely reappearance. It was in 1830 or 1831 that Harding arrived in Boonville. His presence immediately helped George, then twenty, make up his mind. This encounter may have been the most important moment in the life of Bingham, the artist. Certainly it was an occasion of major significance in the history of American art.

The record of Harding's visit in Boonville is not clear enough to determine how much time he and George spent together. But there was certainly opportunity enough for George to display the bits of painting and sketching he had recently completed and for a favorably impressed Harding to offer strong encourage-

ment. After making suggestions for improving his work and giving him badly needed paints and brushes of professional quality, Harding pointed out the best way for Bingham to begin a career as an artist: he advised him to start by painting portraits for money and avoid the traditional path taken by the many aspiring artists who painted land or seascapes.

The astute Harding knew that to take nature as a subject just then would bring George little, if any, financial reward, particularly from his frontier neighbors. Instead, as Harding shrewdly reminded him, he could be sure of his money painting portraits, for his paying subjects were walking the streets around him. In the days before photography, families who wished to retain likenesses of dear ones had little choice but to hope that a painter would come through the neighborhood who could turn out portraits, however primitive some were. As Harding explained to George, by painting portraits an artist's financial reward was immediate. Furthermore, the income could soon be sufficient to pay for trips to New York and Philadelphia, where George could learn higher forms of painting by observing the work of great artists.

At this point in his life, the advice of a professional artist must have been just what young Bingham needed. And for such a person as Harding to emphasize that George indeed had the ability to succeed as an artist must have been heartwarming for the youth. His words would surely have been more convincing than praise from his mother and Mattie Wood. He needed the voice of a knowledgeable male, someone like Harding, to drown out Uncle John Bingham's scoffing at anyone who dawdled over a sketchbook, implying that there was something sissified about a man doing paints. And besides, Harding had reminded George that he, too, had started out in a cabinetmaker's shop and had gone on to artistic success.

Harding's counsel was convincing, and Bingham followed it throughout his career. Of all the paintings created by him, the vast majority were portraits. And it was not until he considered himself financially secure—thanks to doing portraits—that George

would feel he could safely divert some of his time to painting something other than portraits. As George saw it, employment as a portrait artist was no different in purpose than being a cabinetmaker.

Soon, therefore, young Bingham gave his thanks and farewell to the Reverend Justinian Williams, Boonville's chief woodworker, and set out to find subjects willing to pay to have him paint their portraits.

Chapter Three

On the Road

O nce Chester Harding had left for home, Bingham's inspiration came from his admiring pals in Boonville. They watched, amazed, as their chum sketched their likenesses. By late 1832, George felt sufficiently sure of himself to go on the road. He sought portrait business in a number of Missouri river towns, making friends and gaining experience. Wherever he went, George took care to advertise, proclaiming in simple terms that he was able and willing to paint the portraits of citizens— which meant those individuals who could afford to pay him.

In this way, Bingham kept on the move for over ten years, in time extending his territory to cities on the East Coast, including a lengthy stay in Washington, D.C. Harding had advised him that in places such as New York and Philadelphia he could study the achievements of more masterful artists while he continued doing his own work. It was excellent counsel, for once George had seen the canvases of famed painters displayed in the museums and galleries of the large cities, he no longer was content to be just a frontier portraitist. His natural ambition prodded him to go forth and do as artists he admired were doing—while still earning his keep from "doing heads," as George called portraiture.

By now it was clear that Bingham was no ordinary citizen of frontier Missouri. Even physically, he was extraordinary although he was of medium height, five feet, eight inches tall, and his adult weight remained about 150 pounds throughout life. What set him apart from others started with an illness that struck him

during his early travels around Missouri. He caught a form of smallpox near the town of Liberty that left his face pock-marked and his head totally bald. Thereafter, he usually wore a wig to hide what one contemporary called "a great white dome." The result lent him an unusual appearance. This, along with his aggressive presence, often made him the center of attention.

Young George was already known as an energetic conversationalist who could be counted on to have a strong opinion about any subject. Those friends he retained, in spite of his fiery, outspoken nature, were devoted to him, and he did not hesitate to call on them for help, particularly when he needed money, which was frequently. He developed expensive tastes, and he got a psychological boost from having cash always at hand. George was forever dogged by the memory of how poor he and his family had been after Henry Bingham died heavily in debt.

A charming reminder has survived of Bingham's beginnings as a painter. Two of his earliest portraits, completed in 1834, can be admired in the visitors' center at Arrow Rock State Historic Site. There is a bit of irony about these portraits, for they are of the prosperous Dr. and Mrs. John Sappington. The name of Sappington would always be mentioned bitterly by George after he became active in Missouri politics. Not only were the Sappingtons powerful in the Jacksonian Democrat party when George joined the leadership of the opposition Whigs, but one of the family's sons would become a political foe. This was a dozen years after George had begun rising beyond the role of a cabinetmaker's assistant.

Indeed, by 1835, after painting the Sappingtons and other prominent citizens, George set up shop for a time in St. Louis and published a note in the *Missouri Republican,* announcing that "G.C. Bingham, Portrait Painter, respectfully tenders his professional services to the citizens of St. Louis." The advertisement assured readers that the artist could be found in a room above the Shepherd of the Valley printing office on Market Street.

This step had not been taken without the encouragement of a new friend acquired late in 1834 when Bingham briefly shift-

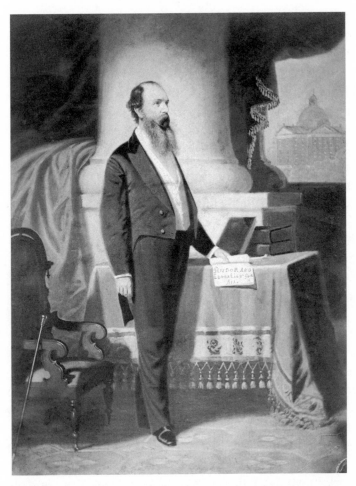

Portrait of James Sydney Rollins (1870). The most significant feature of Bingham's career was his friendship with Rollins. Bingham's debt to Rollins—professional, emotional, and financial—was incalculable. Rollins was as stable and wise as Bingham was impetuous and naive. The artist recognized this contrast and was forever grateful that he could turn to his friend for help, as he did throughout his adult life. Bingham considered Rollins's portrait the finest study of character he had achieved. Fortunately, a photograph of the portrait was taken before the canvas was lost in 1892, when fire destroyed the University of Missouri's Academic Hall. *State Historical Society of Missouri, Columbia*

ed his principal studio from Arrow Rock to Columbia, Missouri. Growing up without a father and lacking any bond with his uncle John, George must have welcomed a masculine figure to admire and to approach for guidance. Such a person was James S. Rollins, who became the most significant individual in Bingham's career. Rollins was an attorney and also an ambitious politician. A year younger than George, he could claim membership in a prominent pioneer family in mid-Missouri that had sent him to study in eastern colleges. When he and George became acquainted, Rollins had just begun his distinguished career in public service, which would eventually make him an influential figure in both Jefferson City and Washington, D.C.

Bingham and Rollins were immediately drawn to each other. They would remain intimate friends for the rest of their lives. It was to Rollins that George invariably turned for comfort and advice—and for money, which the prosperous Rollins readily lent. Besides his vital role in bringing Bingham success as an artist, Rollins both encouraged and cautioned George when the latter turned to political activity. Consequently, it is no exaggeration to say that the enduring achievements of George Caleb Bingham in art and public service were due in large measure to the long-suffering wisdom and kindness of the generous James Rollins.

Historians have received a priceless legacy from the Bingham-Rollins association. George shared everything about himself and his work in candid letters he wrote to Rollins. Nowhere else are there such useful clues about George's personality and life. In spite of his own demanding career—businessman, legislator, congressman, and founder of the University of Missouri, Rollins always found time to answer Bingham, although only the artist's side of this correspondence has survived. Without these letters to Rollins, Bingham's biographers would have to depend upon the comparatively few items remaining from the artist's correspondence with his wives and a very few other individuals.

As his comradeship with Rollins began, Bingham also was forming another, very different bond of great importance. This

was with Sarah Elizabeth Hutchison, who would become his first wife. They were married in September 1836, but not before George had confessed to Elizabeth that earlier he had sought the hand of another young woman who lived in Columbia. Her parents had refused his suit, predicting that, at age twenty-three, he possessed an unpromising future. George waited a year to begin his romance with Elizabeth, the sixteen-year-old daughter of Nathaniel Hutchison, a New Franklin pharmacist. Elizabeth was still attending school when George fell in love with her.

During the twelve years of their marriage, Elizabeth received letters from her husband that are almost as revealing as those he wrote to James Rollins. Not only do these documents depict the young artist's struggle for success, but they also disclose much about young Bingham's personality, as when he admonished Elizabeth on matters of religion. He was alarmed that she seemed to take no interest in spiritual matters. "If anything merits our chief concern, religion does," he informed her. Religious faith not only guaranteed bliss in the hereafter, George assured his betrothed, but "it is the source of our highest enjoyment in this world also. . . . May you possess in full its richest blessings."

By December 1835, however, George's letters to Elizabeth had lost most of this lofty tone. Instead, they became candid accounts of his moods and his yearning for her. Although the pair had been engaged for six months, George had yet to kiss his betrothed. While he admitted that he had lacked the courage to try, he implied that she had given him no encouragement. Had he attempted a kiss, would he have been "repulsed with a severe box on the ear [?]" he wondered.

This was written as George sat in St. Louis, dismayed at how slowly his portrait business had begun in that city. Although he would soon find his talents in demand, George's early struggle in St. Louis left him more than enough time to write frankly to Elizabeth. He spoke of being stuck in a state of melancholy, of how his feelings had "a somber cast," and his "prospects" appeared "dark and gloomy." Even so, George assured his prospective bride that "I have never entirely despaired, and the

determination to do my utmost to rise in my profession has ever remained strong in my mind."

With this sign of George's ambition came evidence that he was maturing creatively. Bingham found he could turn a critical eye on his paintings. He told Elizabeth that although he saw how delighted his patrons were with their portraits, "it is but seldom I can please myself." Nothing he had done so far had left him "perfectly satisfied"; still, George was able to remind himself—and Elizabeth—that "it has been but a few years since I was a barefoot apprentice in Boonville."

In moments of despair, George wondered if he had erred in following an artist's calling with all of its demands—"the mortifications and anxieties that attend the work of a painter" and "the toil and study which it requires to give him success and raise him to distinction." Did Elizabeth realize, he asked, that even now he "had scarcely learned to paint the human face," and that this modest accomplishment was merely one lowly step "toward the eminence" which the art of painting could bring? Nevertheless, George pledged himself to continue striving to improve, even if he had to find his subjects "among the dogs and cats."

At the end of November 1835, George seemed particularly discouraged with himself—but then the next fortnight brought a notable change in his outlook. As it turned out, a little more business was all he needed to be happier as an artist. In two weeks he had completed ten portraits and copied two landscapes by other artists that had been on display in St. Louis. They pictured "bufaloe hunts." What clearly pleased George was that persons who compared his treatment of these hunting scenes with the original paintings thought his was superior. One of those admirers proposed to take George's canvases to Louisville and sell them there—a step "that will serve to make me somewhat known as a painter," he assured Elizabeth. And there was even better news—George could report that he now had "engagements to fill which will keep me busy for two weeks to come."

After the spring of 1836, George Caleb Bingham never again seriously expressed doubt and dismay over his ability as a painter.

He promised Elizabeth that she would receive "no more mel-
ancholy letters from me." His mind then shifted easily from
concern over his career to thoughts of the "bliss" he felt at the
prospect of marriage to the still sixteen-year-old Miss Hutchison.
The ceremony would bring the moment when "I shall be per-
mitted to press you to my bosom and know that you are my
own Elizabeth, and that forever."

Such thoughts may have distracted him from his work in St.
Louis, for George discovered he had consented to paint more
portraits than he could finish. He left town after promising the
disappointed patrons that he would soon return. Meanwhile the
fee he charged for his work now approached twenty-five dollars
and presently would reach fifty, leaving George almost giddy
with the novel sensation of prosperity. He also noticed that as he
left St. Louis the newspaper spoke enthusiastically of his work.
Small wonder that he was in high spirits when he reappeared in
the Boonville area and prepared for his marriage to Elizabeth.

The wedded state did not keep George from going back on the
road. By fall 1836, he was in St. Louis again, where he managed
to find accommodations for himself and Elizabeth. Thereafter,
George was content for a time, completing a portrait nearly every
day, while Elizabeth soon was pregnant with their first child.
George devoted any spare time to studying the few landscape
and other worthwhile paintings owned by local citizens. He also
deepened his friendship with James Rollins, who appeared fre-
quently in the city.

Soon after Isaac Newton Bingham, named for George's late
brother, was born on March 26, 1837, George took his family
down the Mississippi River to Natchez where he had heard there
was demand for his talents. Indeed, so much was the clamor for
his work that George found he could charge sixty dollars for a
portrait, although he claimed that only the high cost of living in
the South justified such an increase in his fee. Actually, the
Binghams' stay in Natchez did occur when a severe economic
depression began in 1837. Prices soared so that the value of
money fell.

While George was quick to blame the financial crisis on the Democratic party and the new president, Martin van Buren, he saw as the chief villain Missouri's Senator Thomas Hart Benton. Bingham and James Rollins were eager to turn Benton out of office. Having become an ardent supporter of the new Whig party, which had arisen in opposition to the Democrats, George seemed to take some glee in reporting to Rollins that in the South, "almost every countenance is shrouded in gloom." Busy though he was, the Missouri artist revealed how then and forever thereafter, politics was certain of a central place in his thinking.

Bingham did not permit the arrival of hard times to push him back into melancholy. Instead, from Natchez he shared with Rollins his aspiration "to attain eminence in the art to which I have devoted myself." He assured his friend that despite undoubted difficulties ahead, "by determined perseverence, I expect to be successful." Of great importance, however, in this expression of the now-familiar optimism was George's acknowledgment that if he was to reach professional success, he would have to leave Missouri and "settle in some one of the eastern cities."

Determined to make this change, George proposed for the moment to leave his wife, Elizabeth, and son with relatives in central Missouri. In July 1837, he chose the village of Arrow Rock, near where his mother lived, as his own intended residence. He purchased a building lot for fifty dollars from Claiborne F. Jackson, who would soon be a major Democratic figure in Missouri and his mortal enemy. Today, visitors to the wonderfully restored town of Arrow Rock can admire the modest house Bingham built for his family, calling upon his skills as a carpenter and cabinetmaker. When it was finished, George's mother, Mary, moved into town to keep Elizabeth company, leaving the Bingham farm in the care of kinsmen.

George's choice of Arrow Rock was appropriate. The village could be said to owe its existence to the Bingham clan since in 1833 Uncle John Bingham had contributed much of the land

required for the expansion of a meager settlement that had stood there since 1821. For reasons unknown, it had first been called New Philadelphia after being platted in 1829. Enlarged by the generosity of Bingham and others, the community then took the name Arrow Rock with legislative approval. The new name was chosen because Native Americans had used nearby outcroppings of flint to sharpen arrows, a location the French had called "Pierre à fleche," or Arrow Rock. Thanks to the town's location on a bluff overlooking the Missouri River valley, the Bingham house offers visitors to Arrow Rock a fine view.

George did not linger long in his new home. He soon headed for Philadelphia and New York City. Thanks to his increased self-confidence, George aimed less for financial profit than for the self-improvement he was certain would come from studying the work of distinguished artists. In the first six months of 1838, Bingham gazed admiringly at the collection of paintings held by the Pennsylvania Academy of Fine Arts. What he saw and copied improved his ability to draw and sketch. He then traveled down to Baltimore and then up to New York City for more study. While George was in New York he took a step that would prove of major importance in his career. He signed an agreement with the Apollo Gallery of Art to produce a painting that the gallery would exhibit in a show later that year.

It was a significant decision by Bingham, resulting from his study in Philadelphia and New York. After observing canvases by Canaletto and Correggio, as well as those by artists closer to home, including Washington Allston and Benjamin West, George found the courage to begin painting in ways more challenging than portraits required. It would have been very easy to go on as a portraitist. He had prospered, and his skill had improved markedly. He was now widely admired for his paintings of individuals, an achievement upon which his mentor, Chester Harding, had congratulated him when the two met during Bingham's stay in Philadelphia. Yet George resisted settling for the easy way, even though it would have assured his family a comfortable existence. Instead, Bingham became enthusiastic

about genre painting, the realm that would ultimately bring him global fame. "Genre painting" is a terse way of saying "pictures of everyday life." As such, it represented a departure from the classical style that had dominated the work of artists in western Europe in the eighteenth century. The new approach was introduced with the courageous start made by Sir David Wilkie (1785-1841), a painter who worked in Scotland and England. His successful depictions of daily scenes gave genre painting almost overnight prominence in Europe after 1822.

The great canvases Bingham would eventually paint, such as those featuring the life of rivermen or the antics of citizens on election day, are perfect examples of genre artistic work. It was in this field that George agreed to submit a canvas for the exhibit scheduled by the Apollo Gallery for the autumn of 1838. His entry, which he completed after he returned to Philadelphia, was entitled *Western Boatman Ashore*. It was his first significant departure from portraits, but unfortunately the work has disappeared so that nothing is known about its character.

George did not linger in the East to enjoy seeing his canvas hanging in the New York exhibit. In late summer he returned to Elizabeth in Arrow Rock, carrying copies of artwork that he intended to use as guides for what he called his "drawing studies"—not that he entirely forsook "painting heads," as portraits were his family's meal ticket. He also brought back to Missouri some important developments in his thinking, ideas that would strengthen his desire to be politically active. These new viewpoints about society and government grew from what he had observed in the cities of the East, where life was much more complex than in the villages and towns of the Missouri River valley.

In letters to Elizabeth, Bingham had admitted that he was impatient with the kind of talk he associated with the Democratic party. He charged the Democrats with attempting to glorify the "common man," claiming that the only sound political wisdom came from deliberations of laborers, farmers, and other toilers. It distressed George to see Philadelphia, "this quiet and

peaceable City," taken over by what he called "a mob-cratic influence." He spoke sarcastically of "the courage of the *patriotic mob*." George had changed almost as much politically as he had artistically during his stay in the East. He had developed a deepening conservative answer to public questions.

George stayed for a time in Arrow Rock before he resumed painting portraits in the more profitable communities of Columbia and St. Louis. One reason he lingered at home was to console a sorrowing Elizabeth. Their second son, Nathaniel, who was born while Bingham was in Philadelphia, had lived but a short time. The bereaved parents took comfort in watching Newton, their first-born child, as he grew in health.

Something beyond family grief prompted George to remain in Arrow Rock during the summer of 1840. That was the year of the presidential election between candidates Martin van Buren and William Henry Harrison, the Whig party nominee. Bingham considered the choice so important that he allowed the campaign to pull him away from the lessons in drawing he had brought from Philadelphia. He even turned a deaf ear to the clamor from those who wished to have their portraits painted.

This deepening interest in politics was due largely to the encouragement of George's friend Rollins, a founder of the Whig party in Missouri. He had recently been elected a member of the Missouri legislature. Bingham eagerly joined Rollins as a hardworking Whig. The young artist was a very adept pupil as Rollins instructed him in Whig doctrine, which called for an aggressive federal government led by men powerful in business, banking, and the professions. Rollins emphasized that there was no place in good government for the "mobs" the young artist had seen in the East. Leaders were needed who understood the need for high tariffs and internal improvements—all aimed at enhancing business prosperity.

Consequently, Bingham and Rollins were determined that Missouri should not remain in the control of Senator Thomas Hart Benton and his fellow Democrats, who insisted on a policy that aimed to keep the nation primarily agricultural and led by

unlettered mechanics and farmers. At least that was the fear of Bingham and Rollins, who predicted that if the Democrats stayed in office Missouri and the nation would be ruined.

Why should Bingham, who came from an impoverished, rural background, hate the party claiming to be for the common man? The answer lies in the sort of company the young artist had been keeping: the prosperous citizens for whom the impressionable George had painted portraits.

Before politics seized George's attention, he had succeeded, by early 1840, in painting six canvases, which he shipped to New York City for display at the National Academy of Design. These pictures are now lost. Although they were more than simply portraits, they apparently were not yet genuine genre studies. As soon as they were finished, George began a very different project, an enterprise which combined his artistic skills with his increasing fondness for politics. The result was a gigantic banner, built like a box kite, that was the feature of a parade during the Whig party's statewide convention held in the summer of 1840 in Rocheport, a river town not far from Arrow Rock.

For several weeks before the convention, George gave his full attention to designing and painting the banner which, because of its huge size, required four men to carry it. Nor was the banner the only contribution that Bingham made to the Whig gathering. Taking time from his painting, he prepared an oration that drew loud applause from the nearly one thousand Whig party faithful who had gathered in Rocheport. Thanks to James Rollins's influence, George had been selected as one of the featured platform speakers. The assignment was no great imposition on him. It required only that he call on the talent for public address he had demonstrated back in Boonville when he had been a stripling preacher.

In both his speech and his banner George evidently made a splendid impression with the crowd. While both his art and his oration have been lost, surviving evidence suggests that Bingham took pains to extol the career and noble character of General William Henry Harrison, the Whig candidate for president. He

also endorsed the Whig party's claim that its policies would strengthen the Union by enhancing commerce on the rivers and by encouraging the railroad. According to Bingham, this policy would unite business, banking, and agriculture as worthy partners in the growth and prosperity of America.

Bingham took delight in emphasizing what he claimed were the tyrannical methods of the previous president, Andrew Jackson, and the present occupant of the White House, Martin van Buren. These were topics that George addressed first in Rocheport and then in a speech he was called upon to give before his neighbors in Arrow Rock during August 1840. Three months later, to the elation of Bingham and Rollins, the Whig party's national ticket was victorious, which meant that Washington suddenly became an attractive place for George to take his thriving career as an artist. It seemed the best location to advance both his artistic and his political aspirations.

Of course moving to Washington was not entirely an easy decision. For while Bingham recognized that he could not mature as a painter by remaining in Arrow Rock, he knew any future political career would be in Missouri. For the moment art won the day, and Bingham went back on the road. A month after the Whigs won the election, George, Elizabeth, and their son, Newton, had settled into Washington life and work.

The family chose to live in a boardinghouse, where Elizabeth had the company of Jane Shaw, a friend from Boonville. George joined another artist in renting a room in the basement of the Capitol, where they established their studio. Bingham's colleague was John Cranch, who, as George discovered, was a first cousin once removed of the elderly John Quincy Adams, sixth president of the United States and, in 1844, a congressman from Massachusetts. This relationship led to Bingham's painting the portrait of President Adams as well as the likenesses of several other notable political figures of the time. Except for the portrait of Adams, few of these canvases survive.

George spent four years in the Washington area. His stay was far from the most productive interval in his career as a painter.

He did little to move ahead in the field of genre painting, thereby postponing his emergence as one of the nation's great artists. Nor did this time in the federal capital lead him to become more sophisticated about politics. For Bingham, the American party division was one between rascals and gentlemen. He saw the Democrats—Locofocos, he called them—as hopelessly "unscrupulous" and even tyrannical. Their behavior left him sick to his stomach, he said, while the noble Whig party had been sent to deliver the nation. He likened President-elect William Henry Harrison to Moses, claiming that both had been called to rescue their people from the burdens of corrupt masters.

While Bingham assured James Rollins that "I am a painter and desire to be nothing else," he conceded that he might feel compelled to shift to politics if "another corrupt dynasty" should again arise. Nor could George forget that, despite his great banner and oration, his beloved Missouri still suffered under the heel of the Democrats. It was therefore no surprise when, in 1844, he kept his pledge and made politics his main interest for a time. To his sorrow, the Whigs slipped out of power almost as soon as they gained it. Consequently, George once again enlisted in the fight against the Democrats in Missouri.

Before the election excitement of 1844 took him away from Washington, George had taken time to consider another side to politics, one that he grasped very quickly. It was a recognition of how public money could be used for the arts, a lesson that stuck with him for the rest of his life. George began to learn it when, while poking around the Capitol, he discovered an artist from Illinois who was painting copies of some of the portraits of the great Americans that hung in the federal Capitol. To his amazement, George found that the work on these copies was being paid for by the Illinois legislature for the purpose of displaying them in the state's capitol. Immediately, George wrote to James Rollins, then one of the few Whig members of the Missouri legislature, urging that he call upon his fellow legislators to support Bingham's painting in an arrangement similar to that of Illinois'.

This request was only the first of many such occasions when

Bingham would unabashedly seek to use Rollins's influence to further his own career. For the moment, it seemed not to bother George that if Rollins did succeed in gaining the legislature's approval to put Bingham to work in Washington, the money would have been granted by the "corrupt" Democratic majority in Missouri's state house. It was sufficient to know that the Missouri legislature would soon move into what he called "a splendid State house" in need of majestic paintings to adorn its walls. So what if the Democrats would be in charge of the building? Suddenly, that prospect was much easier for him to endure so long as the party he detested governed beneath portraits of great Americans created, of course, by George Caleb Bingham.

Reminding Rollins that he knew him to be "a friend to the Fine Arts," George urged him to propose to the legislature, then in session in Jefferson City, that its members commission Bingham to paint copies of the portraits of Washington, Jefferson, and Lafayette that were hanging in the federal Capitol. Not only would this demonstrate that Missouri possessed "a laudable regard for the arts," but the work would be done "at an expense merely nominal." George then loftily added that he wished for the assignment only if the legislature believed he merited it "as an artist." In a postscript, however, he urged: "Please let me hear from you by letter as soon as convenient."

No matter how worthy the cause, Missouri's government was not yet ready to support the work of a painter, despite Rollins's efforts. It would be several years later, after George himself had been a member of the legislature, that he would receive his first commission to paint imposing portraits for Missouri's capitol— paintings eventually destroyed when the building burned in 1911.

There were to be more results from George's stay in Washington than his lessons in political maneuvering. Still in his mid-thirties, he learned something about high living. As he developed a fondness for the good life, his wife, Elizabeth, complained to her parents that her husband "is quite regardless of money." Indeed, the Bingham family's surroundings in Washington brought a much more luxurious and tempting existence

than was at hand in Arrow Rock or even in St. Louis.

Elizabeth Bingham sent a description of their life in Washington to George's mother back in Arrow Rock, where, she reminded her mother-in-law, nothing could be kept a secret, "In your town [where] you all live so much like one family." This was not so in the Binghams' boardinghouse on Pennsylvania Avenue next to the railroad station. Elizabeth reported that there were twenty-one guests, most of them congressmen. The latter took their meals and enjoyed their social life in a parlor quite apart from the commoners. Outside their elegant quarters, however, the Binghams found Washington itself much less attractive than St. Louis—"there is but one street paved," although Elizabeth did pronounce the White House and the Capitol "splendid buildings."

· The food served at the boardinghouse particularly impressed Elizabeth, perhaps because she had the appetite accompanying advanced pregnancy. She spoke of having "cakes, ice creams, mince pies, and a great variety of meats, fowls, and oysters in abundance." Breakfast was available at nine, while the dinner gong sounded at four, and tea was taken at seven. "Very fashionable indeed," Elizabeth observed—adding "rather too much so." She was dumbfounded by the high price of the meals she and George were served.

Suddenly in March 1841, George and Elizabeth's comfortable Washington habits were woefully disrupted by the death of four-year-old Newton, the son in whom George had taken such pride and delight. The stricken father was not much consoled when, a few days later, another son, Horace, was born. George mourned that every sight in Washington now reminded him of the departed Newton, who had been accustomed to trot up to his father's Capitol studio by himself just to keep him company when the portrait business was slow, as it usually was.

To break away from these morbid surroundings, George decided that as soon as Elizabeth and the baby were ready, the family would move into Virginia. He chose Petersburg, a village just across the James River, south of Richmond. The change was also impelled by the death of Bingham's beloved President

Harrison on April 4, 1841, exactly a month after his inaugura-
tion. The Whig party fell into disarray, and Washington lost its
luster for George.

The move to Virginia brought the Binghams little consolation.
Finding few patrons who wished to have their portraits painted,
George had plenty of time to write to his mother in Arrow Rock.
His letters were mostly about his grief over Newton's death, sor-
row that was still fresh six months after the sad day. At the close
of September 1841, he told Mary Bingham of "my bursting heart
and flowing tears, as alone in my studio I read . . . your letter."
Meanwhile, he could only hope "that after all our troubles we
may at last rest as peacefully and quietly as he does."

Having found no peace after six months in Virginia, George
and Elizabeth returned to Washington. In the spring of 1842,
George made one more attempt to find solace in Virginia by
visiting the scenes of his youth in the Shenandoah Valley. Leav-
ing Elizabeth in the capital, he went up to Harrisonburg and Port
Royal, where he was reunited with relatives. The encounter he
most cherished, however, was with "Old Tom," a venerable Afri-
can American who had once belonged to George's father and
grandfather when they were in the milling business. After talk-
ing with Tom and his wife, George departed, listening as the
voice of the elderly black followed him "until I was out of sight."
George told his mother that "I could hear him calling down
blessings upon my head. And I felt that if the prayers of any man
could avail for me, his would."

The Binghams stayed in the Pennsylvania Avenue boarding-
house until late autumn of 1842, when Elizabeth and tiny
Horace returned to Arrow Rock in search of better health. They
remained in Missouri for a year until George's pleas of loneli-
ness enticed Elizabeth to return to Washington in the late spring
of 1843. There she found her husband struggling to find a new
sense of purpose and direction in his profession.

On the one hand, George was unhappy with the source of his
income, "painting heads." On the other hand, while he yearned
for Missouri, he feared that he could not pursue his artistic

career and live in Arrow Rock, "how much soever I might desire it." Believing that he needed more time to think, George exchanged his studio in the Capitol for a quiet room down Pennsylvania Avenue. Here he had even fewer requests for portraits.

Choosing such a location raises an intriguing question. How did Bingham use the long empty hours in his new studio? The answer points to the approach of a profoundly important adjustment in Bingham's professional outlook. He acknowledged that he had begun to consider whether "a great change should take place in my pursuits and feelings." Often, he said, such thoughts were stirred when he took out the sketches he had brought with him from Missouri—drawings of citizens occupied with their routines. These included fishermen, boatmen, cardplayers, huntsmen, and even politicians. Looking at his sketches, George remembered what he had learned from his earlier excursions to Philadelphia and New York, a time when he had discovered how other artists were succeeding professionally by portraying scenes of everyday life.

Bingham found especially impressive among American genre paintings the works by pioneers Emanuel Leutze and William Sydney Mount. He had made a few early attempts to copy them, including the sentimental canvas that he entitled *Going to Market*. Now, in early 1843, Bingham plucked up his courage and made the decision to compete with Leutze and Mount. Portrait painting would no longer be his chief interest. What is even more significant, however, is that he decided he must use the scenes he knew so well—those along the Missouri River valley.

With this new resolve, George went to Philadelphia during the summer of 1843 to study genre paintings that were on exhibit in Philadelphia's Academy of Fine Arts. After several weeks, he had grown so captivated that he took advantage of some portrait business to linger in the city for further study, summoning Elizabeth to join him. What happened after the two returned to Washington in 1843 from Philadelphia remains a mystery. It is known that George became seriously ill, but that he was recovering by the end of August. From that point we can only speculate

about the Binghams until they reappeared in Missouri during the late spring of 1844.

It is a safe guess that George devoted the autumn and winter of 1843-1844 to solidifying his plans to make scenes from everyday life the new focus of his career. Some scholars suggest that he may have begun one or more of his early and finest genre paintings during these last days in Washington—*Fur Traders Descending the Missouri* and *The Jolly Flatboatmen*. While this is possible, it is also likely that Bingham used at least some of his last free moments in Washington to observe politics at the highest level. After all, another presidential election would be fought in 1844, challenging all Whigs to unite to defeat the resurgent Democrats.

The Whig candidate for president would be a person greatly admired by Bingham—Henry Clay of Kentucky—and letters George received from Missouri predicted that Clay would carry the state. Rollins and others wanted George to come home and help assure this great victory. The prospect of again being active in public life made returning to Missouri irresistible. Not forgetting to bring with him a resolve to paint scenes from along the Missouri River, George reappeared in Arrow Rock early in the summer of 1844. No sooner was he back, however, than he faced once again the frustration posed by the lure of two very different callings in life. Could he be both a politician and an artist?

Chapter Four

Painting or Politics?

S oon after the Binghams returned to Arrow Rock in the sum-
mer of 1844, the family welcomed a daughter, Clara. The
birth did not keep George close to home. He was immediately
drawn back into mid-Missouri politics and the business of creat-
ing gigantic banners, which may have encouraged him momen-
tarily to believe that he could combine his zeal for politics with
his enthusiasm for painting. Leaving Elizabeth and the children
in the care of his mother, George began playing politics mainly
in the counties of Saline, Howard, and Boone. He received an
enthusiastic welcome from Whig partisans, who recalled his
fiery speeches of 1840, and he was in demand as both an orator
and an artist.

In 1840, he had painted only one banner; now George found
time to create three such projects. The newly self-confident artist
assured James Rollins that the banners would be fine enough to
merit preservation as relics. Actually, for many years they were
indeed cherished in central Missouri, but ultimately all were
destroyed by fire in a building in New Franklin where they had
been on display.

For the 1844 campaign, the Whigs held their statewide con-
vention in Boonville, where they gathered to begin the fight to
elect Henry Clay. Among the many requests for banners George
received, he gave the one from Boonville as much attention as he
could, but the principal ones he completed were for Boone and
Howard Counties. Each banner towered between seven and

eight feet in height. George charged sixty dollars apiece and jus-
tified his fee by insisting that he must paint on linen—"the only
material on which I can make an effective picture," he told James
Rollins. The banner should be "substantial," Bingham explained,
because it must be strong enough to bear up well when held
aloft in a parade, particularly if one of Missouri's windy summer
storms should be brewing.

Although these latest banners were merely two-sided, unlike
the boxlike one created for 1840, each still required four men to
carry it. Bingham used political aplomb in designing the ban-
ners, one of which portrayed Clay as a great statesman, the
architect of the American System. The other showed Clay as a
"plain farmer." As Bingham described it to Rollins, on the back
of one banner he had pictured "a large buffaloe broken loose
from his keepers . . . in the fury of his unbridled career." George
intended such a huge creature to stand for the Whig forces that
would hurl James K. Polk, Clay's Democratic opponent, and his
followers in all directions. It displayed the sort of total Whig vic-
tory that Bingham believed was necessary for the continued
well-being of Missouri and the United States.

Henry Clay was defeated in 1844, but his loss did not end
Bingham's devotion to politics. With Rollins's encouragement,
he began planning a political role for himself much more signifi-
cant than painting banners and haranguing crowds. His eye was
on the election two years later when the state would choose
statewide and local officials. Then George intended to run for a
seat in Missouri's General Assembly.

While he awaited 1846, Bingham carried out a plan he had
begun to form while he was in Washington and thinking about
the changes rapidly taking place in the field of American art.
These changes perfectly suited his belief that an artist's work
was a business. George knew that portraiture was the simplest
sort of enterprise whereby an artist-businessman could be quick-
ly compensated by the consumer—the subject of the portrait.
But how would profits result if he turned to working in the
genre style, one that usually entailed large canvases whose com-

pletion required the investment of far more time than painting a portrait?

George found the answer in the existence of the American Art-Union located in New York City, a discovery he made shortly before he returned to Missouri in 1844. The help of the Art-Union, Bingham soon realized, could be the means by which he could begin to enter competition as an American genre painter. Consequently, in 1845 he started what would be a helpful but stormy association with the organization, which lasted until 1852 when the Art-Union was dissolved. The collaboration accounts for the astonishing acclaim his genre paintings had begun receiving by 1850. After five short years, he had come to be called "The American Artist" and "The Artist of the West."

The Art-Union represented an ingenious means of helping artists become well known and prosperous, even those who might work in such remote places as Missouri. Despite its somewhat misleading name, the Art-Union was not an association of painters and other artists; it was a not-for-profit organization of citizen-members from around the nation who paid five dollars as annual dues, a not-inconsiderable sum before 1850. The management of the Art-Union used the income to purchase paintings newly completed by artists who had submitted them for consideration by the Art-Union's executive committee.

The selected paintings were exhibited in New York City, then they were distributed annually to members by means of a lottery in which names of members were drawn out of a hat. Since the membership approached ten thousand, very few persons, perhaps four hundred, could ever win an original painting. So the Art-Union leaders customarily selected one or two of the best canvases from among a year's acquisitions and had them engraved. Prints from these engravings were then distributed to the great majority of members who had been luckless in the annual drawing. This procedure required that the Art-Union produce as many as eighteen thousand prints of a particularly favored lithograph.

Those artists whose work was thus distributed to Art-Union

Themes: Portraits and Scenes

Commentary

Horse Thief (1851-1853)

This landscape painting by Bingham deserves first place among
the illustrations included in these pages. *Horse Thief* was only
recently found. Art historians have long believed that Bingham
painted such a canvas between 1851 and 1853, but, like much of
his work, it was unsigned, and it disappeared after completion.
Living often on the move, Bingham did not keep a log of paintings
produced or sold, preferring to function mainly by verbal agree-
ment. Consequently, for nearly 150 years *Horse Thief* remained
among perhaps one hundred paintings of Bingham's that schol-
ars considered to be missing. There was one clue, its title.

In 1999, *Horse Thief* was found, and research confirming its
identity was completed in 2004. Thanks to the courtesy of the art
historian Fred R. Kline, its discoverer, it is reproduced here and
for the first time. Kline, president of Kline Art Research
Associates of Santa Fe, New Mexico, has been searching for and
attributing "lost art" for nearly thirty years. Many of his notable
discoveries have been acquired for museum collections, includ-
ing the Pierpont Morgan Library, J. Paul Getty Museum, and the
Metropolitan Museum of Art.

The story of how Kline located and identified *Horse Thief*
demonstrates once again that the search for works of art or man-
uscripts frequently produces surprises and suspense. Often
scholars stumble across interesting objects not knowing what
they have uncovered until after months or years of study. Kline's

undertaking illustrates the careful study that he and other art historians must pursue in hope of making a convincing identification and attribution of a painting.

At first, Kline had no idea that he had found a missing canvas by Bingham. He and his wife and partner, Jann Kline, who is also an art historian, were browsing in a Texas antique shop on behalf of a client when they noticed a painting leaning against a wall in a dark corner. Dusting it off and bringing it into the light, they could see that it was a splendid nineteenth-century landscape in remarkably good condition. The Klines purchased it and brought it to their research center where it joined other paintings and drawings being studied.

Kline sought to identify his Texas find first by reviewing work of nineteenth-century American landscape artists. As Fred was examining the closely related work of Thomas Cole, Jann Kline commented that she saw a Bingham quality in their Texas discovery. This inspired observation quickly led Kline to his books on Bingham, where he found enough similarities in style to make Bingham the main subject for the next phase of research. Kline had to consider the vast field of nineteenth-century American landscape artists before he could eliminate all but Bingham as the painter of *Horse Thief*. As it turned out, this process occupied the next four years of gathering and interpreting research.

Among the highlights was tracing Bingham's important association with Goupil and Company, a Franco-American art organization whose stencil imprint with the date of 1851 was on the back of the canvas. He went on to compare favorably the composition of *Horse Thief* with that of ten other landscapes Bingham had painted in the 1850s. Also, five of Bingham's drawings were found to be linked in style to the mystery painting. Still another step led to proof that the precise and carefully drawn tiny human and animal figures in the canvas matched the style of those rendered in many of Bingham's other paintings. And lastly, the apparent subject matter was found to have been important for the politically active Bingham, who had made as one of his concerns the rising crime of horse thievery—the first anti-

horse thief association in America was being formed in Missouri at that time.

All these assessments confirmed Kline's belief "that George Caleb Bingham's hand and his mind have come together with vigor and originality in *Horse Thief*, [making it] an imaginative landscape of key importance in Bingham's body of work." Scholars of Bingham's work and career with whom Kline shared his findings have agreed with his attribution of the canvas to the brush of George Caleb Bingham.

Self-Portrait

After considerable success in painting the portraits of others, Bingham was ready by 1835 to depict himself. He was then twenty-four years old, working in St. Louis, and soon to be married for the first time. In this portrait he has the appearance of a well-dressed young gentleman of St. Louis. He had recently lost his hair following a smallpox infection, but the portrait conceals the fact.

Three photos: Bingham home in Arrow Rock, Arrow Rock Tavern, and old Arrow Rock (Saline County) Courthouse

During much of the 1830s and '40s, Bingham owned this home in the river village of Arrow Rock, Missouri. He was not often in residence, absent while painting and studying in Philadelphia, New York, and Washington. The cottage also served as a refuge for his mother, Mary Amend Bingham, when she wearied of life on her farm outside of town. The house has been designated a Missouri State Historic Site as well as a National Historic Landmark. Guests are welcome to visit it, thanks to the Friends of

'

Arrow Rock, Inc., a historic preservation organization, and to the Missouri State Park Service. Because of their efforts, the village where the artist and his family lived for many years seems very much alive, a mood encouraged by the presence of other historic structures, including two pictured here. One is the Arrow Rock tavern (1834), located not far from the Bingham residence. The tavern was used by Bingham as one of the settings for his series of election canvases. The other building shown is believed to have been the county's first courthouse. The building was so modest that Bingham pictured it much larger to make it a background worthy of the important scene he depicted in *County Election*.

Portrait of Dr. John Sappington (1834)

This portrait and the next are the earliest known to survive from among Bingham's youthful attempts to "paint heads." That Dr. Sappington posed for Bingham was a tribute both to the subject and the artist. Not only was Sappington the leading citizen of Arrow Rock and Saline County, but he was also nationally and perhaps internationally renowned for his early and courageous advocacy of the use of quinine to treat malaria. A cultivated, well-traveled gentleman, Sappington recognized that it would not be a waste of time to sit for a portrait by young Bingham.

Portrait of Jane Breathitt Sappington (1834)

Jane Sappington brought to Missouri the genetic line of one of Kentucky's most distinguished families. The Breathitts had supplied their state with more than one governor as well as the name of one of the commonwealth's most colorful counties. Mrs. Sappington carried on this tradition in Arrow Rock when several of her numerous offspring became important Missourians. Daughter Lavinia married M. M. Marmaduke, eighth governor

of Missouri. Jane's grandson, John Sappington Marmaduke, was also a governor of Missouri. As if this was not enough distinction, three of Jane's daughters in succession married the colorful Claiborne Fox Jackson, another governor of Missouri and Bingham's enemy during the Civil War. Jane's son, Erasmus Darwin Sappington, defeated Bingham in a hotly contested election for a seat in the state legislature in 1846, but the artist beat him soundly when they faced each other again two years later.

Portrait of Sallie Hall Todd and her daughter Matilda Tete Todd (c. 1860)

This was one of the first studies Bingham completed after he had returned to Missouri in 1859 from Germany and resumed painting portraits. Bingham is said to have considered the portrait of Sallie Hall Todd, a resident of Columbia, one of his most successful. Bingham also painted other members of the Todd family, including Sallie's husband, Robert Levi Todd. His likeness was destroyed in a fire at the University of Missouri in 1892. Sallie Hall was the half-sister of Matthew Walton Hall, whose brick house, built in 1846, still stands in Arrow Rock. Sallie was born in Lexington, Kentucky, on October 25, 1827. After coming to Columbia she married Robert Levi Todd in 1850. He was a cousin of Mary Todd Lincoln. Sallie died on July 9, 1863. Matilda Tete Todd, the child in the portrait, was Sallie's fourth, born on January 18, 1859. The portrait now hangs in the dining room of Sallie's great-great-nephew Thomas B. Hall III.

Portrait of Dr. Benoist Troost (1859)

Some admirers of this likeness insist that it is Bingham's most endearing portrait. Apparently begun shortly before the subject's death in 1859 at age seventy-three, the painting was com-

pleted a few months later. Born in Holland, Troost settled first in St. Louis, where Bingham probably met him, then he moved on to Kansas City, where he became much more than the local physician. Indeed, one wonders how he had time to practice medicine. In 1848, he began construction of the first hotel in the town, the Gillis House—named after Troost's future brother-in-law, William Gillis, who became the proprietor when, despite his advanced age, Troost headed for California's goldfields. The doctor was one of the lucky ones, returning to Missouri a very wealthy man—who became more so when he invested in lands surrounding Kansas City. Troost is remembered for the good humor that Bingham caught so admirably, and a major street in Kansas City is named for him.

Photo of the grave of Mary Amend Bingham, the artist's mother

George Caleb Bingham's career would be unimaginable without the shaping influence and support provided by his mother. When Mary Bingham died in May 1851 at age sixty-four, George was in New York City, painting his election scenes and trying to sell these and other works. The news of his mother's death made him hasten back to Arrow Rock where he went at once to sit beside Mary's grave. He could think of no achievement of his that was not due to his mother's encouragement. The most important was that, as a single parent and a teacher, she had made it possible for her talented son to grow as an artist. Fortunately, Mary Bingham has been appreciated in her own right. The Daughters of the American Revolution have placed a permanent marker at Mary's grave, paying tribute to her remarkable story as a Missouri pioneer.

Horse Thief

Private collection, Santa Fe; photo courtesy Kline Art Research Associates, Santa Fe, N. Mex.

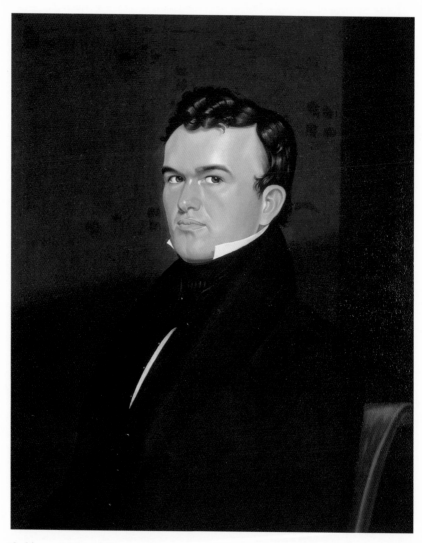

Self-portrait of the artist

Saint Louis Art Museum, Eliza McMillan Trust

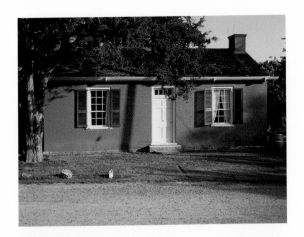

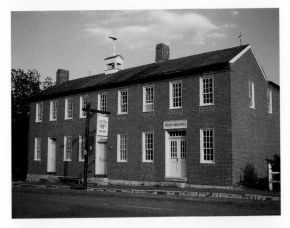

Bingham house in Arrow Rock, Arrow Rock Tavern, Saline County Courthouse

Photos by Thomas B. Hall III

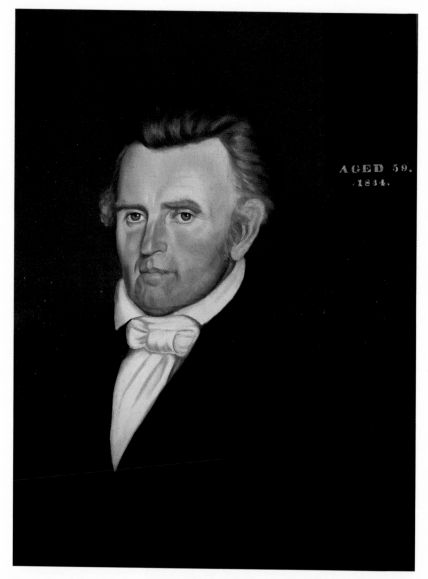

Dr. John Sappington

Missouri Department of Natural Resources, photo by Michael Dickey

Jane Breathitt Sappington

Missouri Department of Natural Resources, photo by Michael Dickey

Sallie Hall Todd and her daughter Matilda Tete Todd, c. 1860

Photo courtesy Thomas B. Hall III

Dr. Benoist Troost, 1859

Nelson-Atkins Museum of Art, Kansas City, Mo. (gift of the Board of Education of Kansas City, Mo.), 35-42/1, photo by Jamison Miller

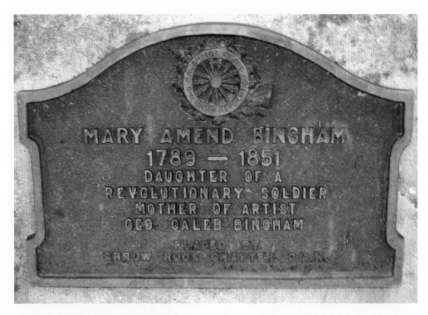

Grave of Mary Amend Bingham, George Caleb Bingham's mother

Photo by Thomas B. Hall III

members could expect to become household names around the United States, if for only a moment. One artist whose career was thus enhanced was Emanuel Leutze, a leading genre and history painter of the time. George Caleb Bingham was another. During his association with the Art-Union between 1845 and 1852, twenty of Bingham's paintings were purchased by the organization, which also occasionally featured the artist himself in its publications.

Art historians continue to debate when Bingham actually started seriously to paint genre subjects. It seems likely it was while he was still in Washington that he began to sketch what became his first great canvases by relying on the drawings of citizen types he had brought with him from Missouri. It would have taken such preliminary work to make possible the magnificent paintings he began producing immediately after designing the Whig banners. A year after his return to Missouri, George had completed four paintings of such superior quality that each was purchased by the Art-Union. One of the four remains today widely considered to be the finest of Bingham's many great canvases: *Fur Traders Descending the Missouri.* Of the three other paintings, two disappeared after the Art-Union's annual drawing awarded them to two members. We know George had entitled one *Cottage Scenery* and another *Landscape.* (Later, many Bingham works would be known simply as "landscape.") The fourth painting, *The Concealed Enemy,* survived. It shows an Osage Indian warrior hiding high above the Missouri River while apparently watching a target below.

None of the four paintings was selected as the print worthy of being sent to all members. This honor awaited one of a group of four canvases that George submitted the next year. The Art-Union board chose George's *The Jolly Flatboatmen* as one of two works that were to be lithographed. Originally, George called the picture *Dance on the Flat Boat,* but the Art-Union's executive committee renamed it—and so it is known today. *The Jolly Flatboatmen* remains one of America's favorite artistic scenes along the Missouri River.

Obviously, during 1845 and the first half of 1846, Bingham must have worked diligently at more than portraits. He could afford to ease up on painting heads, for *The Jolly Flatboatmen* brought $290 into the Bingham household. But if any of George's friends believed that his amazing artistic productivity meant he had put politics behind him, they were mistaken. By the summer of 1846, George was back in party struggles and displaying an unprecedented seriousness of purpose. Once again, he considered running for office, in this case a seat in the Missouri House of Representatives.

Actually, this spectacle of an artist seeking a seat in the state house proved not as strange as it may have seemed. Before he decided to run for the legislature, Bingham deliberately set out to combine politics and art. His strategy was to establish another art studio in the very thick of Missouri politics. At the close of 1844, he began working in the state capitol building in Jefferson City where, to the casual observer, George probably appeared to be doing portraits of Missouri's statesmen. Actually, however, he was even busier trying to persuade these legislators to commission him to paint an historical scene featuring Andrew Jackson in life size. This painting was to hang at the front of the house chamber. If a joint resolution passed, the legislature would authorize that the impressive sum of one thousand dollars be paid Bingham for his work.

Although persons supporting the resolution spoke of George as "a native artist of great excellence," the sentiment failed to carry the day. In late March the resolution was voted down. A sadder and wiser Bingham packed up his brushes and oils and retreated to his studios in St. Louis and Boonville where he plotted how he might soon return to Jefferson City, this time as a member of the legislature. For a time, it appeared that he would succeed. In 1846, George became the Whig nominee for representative from Saline County, where, despite his wanderings, he legally resided as a citizen of Arrow Rock. Although his Democratic opponent was an experienced politician with the unforgettable name of Erasmus Darwin Sappington, Bingham won

473 to 470. Even with the narrow margin, it was a remarkable victory, for Missouri was a stoutly Democratic state.

Leaving Sappington to talk of challenging the result, George headed for Jefferson City where, in cases of disputed election outcomes, the legislators themselves chose the victor. The house, where George aimed to sit, was made up mostly of Democrats. At first, Bingham apparently could not believe that even such an overwhelming opposition would deny him his seat, and he seemed in jovial spirits as the house assembled. He assured James Rollins that "when the evidence shall be read in the legislature, I do not think a loco foco [extreme Democrat] even can vote for my expulsion without a blush." So cheerful was Bingham that he indulged in uncharacteristic teasing in his letter to Rollins. Since he and Rollins intended to share quarters in Jefferson City, where Rollins was also a member of the legislature, George wrote banteringly about his own behavior, urging his friend to be patient with him—while "it is true that I abstain from wine, [I have] rather an unchristian fondness for women."

But as the time approached for house members to decide between Sappington and himself, George's mood changed. He allowed his uneasiness over the outcome to produce an emotional outburst in a letter to James Rollins that he would regret. He said that "an angel could scarcely pass through what I have experienced without being contaminated," adding: "God help poor human nature." Now anticipating that he would lose his seat, Bingham vowed that as soon as the house acted, "I intend to strip off my clothes and bury them . . . and keep out of the mire of politics *forever*." He would soon reconsider these words, spoken in such haste.

Bingham was confirmed in his seat by committee action, which should have decided the issue, but Democratic maneuvering brought the case before the entire house, where there were only twenty-three Whigs to seventy-seven Democrats. While Sappington hired the state's attorney general to plead his case before the house, George, who was now thirty-five years old, acted as his own spokesman. In so doing, he may have

contributed to his loss by sarcastically suggesting that no rational-minded member could possibly doubt that George Caleb Bingham deserved to represent Saline County. After all, did he not have common sense and truth on his side, he asked the members?

This remark was more than enough. But George's tirade was not finished. He went on: "I am not a politician by trade! I am not one of those whose sole study is to enrich themselves by the spoils and emoluments of office." Nor did he know "the wiles and windings of political intrigue." Surely George must have realized that he was insulting a chamber filled with men who prided themselves on being politicians. It was therefore hardly a surprise when the house voted fifty-two to thirty-three to give the seat to Sappington.

George left Jefferson City, vowing never to return. While his wounded spirit healed, he gave his attention to his genre painting—thus raising the question: what might the history of art have lost had Bingham been allowed to take his seat in the house? He might have succumbed to the political virus, leaving unpainted many wonderful pictures, but instead, while sulking after his defeat, George began adding handsomely to his growing array of canvases.

Two of these enlarged his river series, *Lighter Relieving the Steamboat Aground* and *Raftsmen Playing Cards*. The first, now hanging in the White House—perhaps appropriately—could be considered a political document. It pictured the occupants of a flatboat heading upriver to rescue a steamer immobilized on a sandbar possibly because—at least as Bingham and his fellow Whigs loudly complained—the Polk administration had refused to support legislation intended to improve river navigation. Bingham and Rollins were particularly vocal in their support of all federal appropriations aiming for better roads and rivers.

More significant, however, was Bingham's change in subject. After his defeat, he began what became known as his political, or election, series. The first to be finished, painted in 1847, was *Stump Orator*. After being acclaimed in Missouri's newspapers, it

was won by an Art-Union member from Georgia. Many of the figures and postures it contained were among those Bingham would use frequently in other election canvases, particularly the highly successful *Stump Speaking,* which he painted in 1854. A number of the persons portrayed in both were said to resemble Missourians against whom Bingham had fought during the battle over his legislative seat.

Apparently working on his election paintings led George to forget his decision to abandon politics. He put aside his paints and brushes in midsummer 1848 and prepared for another battle. His second run for the Saline County seat in the legislature opened with him as the featured speaker when the Whigs convened in Boonville. Bingham added to his repute as an aggressive orator at this appearance, which helped him recapture the seat he had lost two years earlier. He won by nearly thirty votes, a margin that Sappington did not challenge.

For the moment, Bingham seemed to have everything going his way. He was an officeholder and a prosperous artist, thanks to the money being paid to him by the New York Art-Union. Consequently, as a man of thirty-seven, it was easy to assure himself that he had accomplished wonders. And this seemed doubly so when, to George's delight, Elizabeth enlarged their family by another son, Joseph Hutchison Bingham. But then George's world momentarily fell apart.

On November 24, 1848, as George prepared to take his seat in Jefferson City, his beloved Elizabeth died at age twenty-nine, a victim of tuberculosis—the disease then commonly called consumption—which killed many Americans in the nineteenth century. Her death scene was described by George's mother, Mary, in a letter to his brother Henry, who was living in Houston, Texas. According to Mary, Elizabeth endured "longer and more severe suffering than is commonly allotted to mortals." Yet, with George sobbing at her bedside, Elizabeth had shown "fortitude and resignation." She was, said the eloquent Mary Bingham, "as much composed as if she were going to sleep." Asking George to stop weeping, Elizabeth assured him that "we must part and I

The Missouri House chamber in the capitol. This room was almost as important in Bingham's life as his various studios. The photograph shows the Bingham portrait of General Nathaniel Lyon, which was painted after his death at the Battle of Wilson's Creek. It was destroyed when the capitol burned in 1911. Bingham served one term in the legislature before deciding that he could be more influential by using his artist's brush. Not that he was a reticent member of the House of Representatives, for he worked closely with his friend James Rollins, a state senator at the time, to defend causes favored by the Whig party, especially party efforts to subdue the antagonisms between North and South. *State Historical Society of Missouri, Columbia*

have more to leave you than you have to lose . . . I want to tell you all to meet me in heaven.'"

After Elizabeth died, Mary predicted, "Poor George is destined to be a lone wanderer." His sister, Amanda, said he had suffered a wound "which time cannot heal." George proved them to be poor prophets, for within thirteen months he had married again. Before that event, however, George tended to forget his personal loss in the excitement of the legislative session during which he took his first seat.

There was plenty of heated debate in Missouri's capitol building during the winter and spring of 1849, with Representative Bingham doing his best to keep the controversy fueled. He displayed unusual skill for a newcomer; in Washington he had learned much about parliamentary maneuvering from observing hours of proceedings in Congress. The issue in the Missouri House that drew Bingham's skill for debate was the Democratic majority's support for the expansion of slavery in the territories of the United States. This growth had become possible because of America's victory over Mexico in the war that ended in 1848, just before Bingham entered the legislature.

The war had caused much controversy in Missouri and elsewhere. Bingham and Rollins agreed with those of both parties who had opposed the war on the ground it was a scheme to bring into the United States a region where slavery could thrive. This appeared confirmed when the area wrested from Mexico was seen to stretch mostly westward of the Southern states and within easy reach of slaveholders interested in migrating. These settlers could be expected to organize their regions into federal territories and then clamor to be admitted into the Union. Bingham and many others believed this territorial growth would produce nothing but states sympathetic to slavery and threaten the congressional balance between slave and free states, a balance believed essential to the preservation of the Union.

Siding with Bingham during the legislative session of 1849 was, of course, his intimate friend, James S. Rollins, who had recently been defeated as the Whig candidate for governor but

who sat in the state senate. Probably the most powerful Whig in the legislature, Rollins was in a position to help Bingham receive what proved to be an important post during that session. He was named chairman of the House Committee on Federal Relations. While ordinarily insignificant, the committee became crucial when the legislature debated the possibility of slavery's movement into the new territories. It was the Bingham committee's task to consider and recommend to the house the stand Missouri should take on proposals being heard in Congress calling for slavery to be prohibited in the land acquired by the Mexican War.

Along with most Missourians, Bingham remembered how his state had entered the Union with no restrictions on slavery. That decision was part of a congressional compromise in 1821 that sought to preserve national unity. It managed to do so by admitting Maine as a free state but avoiding the question of whether Congress had the power to control the movement of slavery within the U.S. Now, twenty-five years later, Bingham and other Whigs had come to believe that in the interest of preserving the Union, the federal government could and should halt the expansion of human bondage. There was irony in his stand, for Bingham and members of his family were still slaveholders.

Beyond feeling that slavery should not expand, Bingham believed in the sanctity of two features of American nationhood—that of keeping the federal Union unbroken and the principle that the people must govern themselves. When these two precepts clashed with the question of allowing slavery to expand, the result was highly combustible. Bingham found out just how explosive when he used his role as chairman of the House Committee on Federal Relations to write what were known as the Bingham Resolutions. These proved to be the most important achievement of his career in politics and brought many Missourians for a time to associate George's name with public affairs rather than fine art.

The Bingham Resolutions were put before the house in opposition to sentiments called the Jackson Resolutions that had been approved by the Missouri Senate. These had been brought for-

ward by Claiborne Fox Jackson, a powerful Democrat in the senate—and Bingham's foe in central Missouri. The Jackson Resolutions asserted it was Missouri's opinion that the federal government could not legislate regarding slavery in the territories; his purpose was to compel Missouri's representatives and senators in Washington to take this position. This decree would have forced Missouri's spokesmen always to side with representatives of the slaveholding states.

The Jackson Resolutions sounded an ominous note in George Caleb Bingham's opinion. For him the issue was not so much freedom and bondage as it was the preservation of the Union. This was the stance Abraham Lincoln would take in 1860 and the reason Bingham eventually became an ardent supporter of Lincoln. As a state legislator in 1849, Bingham sought to lift his state's outlook above even such a potent issue as slavery. He wanted Missourians to acknowledge that the most important consideration was the preservation of the federal Union. For George, the Union was the cornerstone of popular government. On this issue, he stood with two admired Whig senators in Washington, Henry Clay and Daniel Webster. But he was most deeply touched by the defense of the Union made by former President John Quincy Adams, who sat in the U.S. House of Representatives.

Consequently, Bingham was determined to defeat the Jackson Resolutions when they came before the Missouri House of Representatives. With the help of some Democrats, he persuaded his committee to recommend to the house that the Jackson Resolutions be rejected and that resolutions written by Bingham be adopted by the house. The Bingham resolutions offered a masterful compromise that breathed the spirit of national unity.

To present his—and his committee's—position, Bingham addressed the house on February 26, 1849. Carefully, he conceded that while Congress had power under the Constitution to affect slavery in the territories, his resolutions would have Missouri urge that Congress use this authority with the interests of all sections of the Union in mind. The federal government should

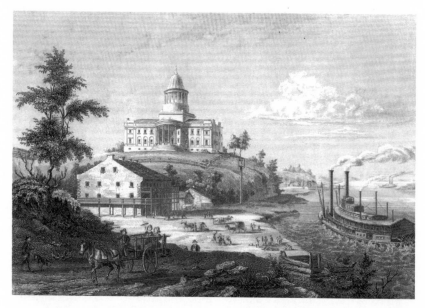

The capitol of Missouri as pictured in Bingham's time. The state capitol of Missouri has had more than one unhappy life. The first of the structures burned in 1837. It was rebuilt in 1842 for the price of $175,000. The building here pictured was the one in which Bingham served first as legislator and later as a state official. He also maintained a studio in the capitol, particularly when he needed to lobby the legislature. It sat on the bank of the Missouri River at the southernmost point before it turned north toward St. Louis, symbolically marking the dividing point in Bingham's era between Missouri's northern and southern sentiment. *State Historical Society of Missouri, Columbia*

be guided by justice as well as by both the letter and spirit of the Constitution.

George's speech before the Missouri House invoked the presence of George Washington, whose farewell address had advised the nation to keep it a sacred duty to remain attached to the national Union. Taking this as sacred scripture, Bingham contended that "regardless of the railings of fanaticism, either in the north or south," all Missourians should "pledge ourselves, come what may, whether in prosperity or adversity, weal or woe, still to stand by the Union."

There was one other point that George could not resist emphasizing in his remarks. He insisted that ultimately it must be the citizens from all parts of the Union, not the legislatures, who make decisions in all matters of national concern, including slavery. This reverence for popular will was fed by George's still-burning resentment over how, two years earlier, the legislature had denied him a seat bestowed by a vote of the people of his district—even if the margin had been only three votes.

Unfortunately, Bingham's luck had not improved. On March 7, 1849, by fifty-three to twenty-nine, the house rejected the Unionist stand offered by Bingham, and it approved the Jackson Resolutions by nearly the same margin. The defeat in no way diminished George's belief in other Whig principles. He could be counted on to vote on behalf of legislation that would help build roads and railways, and he did his best to keep taxes from bothering stockholders. He joined enthusiastically in opposing a resolution brought forward by Democrats that praised the administration of President James K. Polk.

Bingham, however, was soon beyond caring what was said in Jefferson City because he had the exquisite pleasure of public praise from his new hero, Senator Thomas Hart Benton. Benton was a stouthearted Unionist, even if he was a Democrat. Speaking in Claiborne Jackson's hometown, Benton called the resolutions bearing the local man's name "a disgrace to the State." He lauded Bingham's resolutions as "patriotic" and showing that "the people of Missouri love the Union and are in favor of main-

taining it at all hazards." It was a glorious close to this phase of Bingham's political career.

Now the artist in Bingham took command as he considered new approaches to genre painting. He refused to seek reelection to the legislature. In those days, terms in the Missouri House were limited to one session with the legislature convening only every other year. Experience as a politician and the legislative debates in which he had participated gave Bingham a new setting and cast of characters for his paintings.

Up until then, all but one of his genre scenes had glorified the men who belonged to the Missouri River. The exception was *Stump Orator*. With the legislative session behind him, George decided to exchange the rivermen for figures that could represent the life of politics and politicians, which for him meant depicting how the will of the people came to be developed and enunciated.

Consequently, while Bingham may have suppressed his political ambitions for a decade, politicians and politics dominated his genre paintings. His decision in 1849 to shift his focus from rivermen to would-be statesmen opened an era in which George Caleb Bingham reached the pinnacle of his attainment as a painter. And what a splendid success it would be!

Chapter Five

The Business of Art

The decade 1849 to 1859 was by far the most significant in George Caleb Bingham's career as an artist. It began with him, still grieving over the death of his wife, Elizabeth, choosing to leave politics in order to devote himself fully to painting and to the business of being an artist. After 1849, being a business-man seemed at times to shape Bingham's approach to art. Even-tually, his economic zeal not only made him a peddler of art in America, but it also led him to live for a time in Europe.

Consequently, the 1850s found Bingham often frantically busy. He kept the village of Arrow Rock as his home, but his Missouri studios were principally in Columbia and St. Louis. Always a good family man, George sought to keep a custodial eye on his relatives, most of whom lived around Arrow Rock. The size of the Bingham clan had diminished, thanks mostly to the gradual freeing or sale of the slaves brought by the family from Virginia. The census of 1850 reported that George's sister, Amanda, no longer owned slaves. Mary, George's mother, recorded three slaves in that census, down from the seven she had claimed in 1840. As for George, the 1850 census listed him as owner of two slaves, a significant drop from the eight he had declared ten years earlier.

The census taker noted in 1850 that George's age was thirty-nine, his profession was artist, and he had only two children, Horace, age nine, and Clara, five. The baby, Joseph Hutchison Bingham, had died soon after Elizabeth. For George, however,

this distressing loss had doubtless been eased by another change the 1850 census reported—George had remarried.

That event must have astonished his mother. After Elizabeth's death, Mary had predicted that George was doomed to roam the earth alone. But the bereaved widower had other ideas. On December 3, 1849, he married Eliza Thomas, daughter of the Reverend Doctor Robert Stewart Thomas, a Baptist minister who had been educated at Yale. Thomas was a professor at the University of Missouri when his daughter married Bingham. Eliza was twenty-one.

Bingham family lore claims that when Eliza visited George's studio in Columbia during the spring of 1849, the artist had been much taken by her beauty. Their meeting occurred soon after the close of the legislature and a few months after the death of the first Mrs. Bingham. Several days after meeting her, George left for a summer of hawking his paintings in New York City. Busy though he was, Bingham's self-proclaimed "unchristian fondness for women" apparently kept young Eliza Thomas much on his mind. In the autumn, after returning to Missouri, George wooed Eliza in a whirlwind courtship that led to their marriage in December.

Soon after the wedding, the bridal couple went on the road, with George both painting and selling his work. The arduous traveling life proved a challenge to Eliza's delicate emotional and physical health. Less than two years after her marriage, she had to leave George for several months in order to recover herself in the quiet of Louisiana. George's own usually sturdy equilibrium had been upset when his mother suddenly died in Arrow Rock early in May 1851. Leaving Eliza in New York City, George rushed back to Saline County to brood as he sat at her grave. Thereafter, he always delighted to exclaim over his mother's remarkable career, recalling her as a Missouri pioneer who educated and encouraged her children, as well as youngsters from other families in early Arrow Rock.

Before her death, Mary Bingham had been caring for George's children, Horace and Clara, while their father played the role of

roaming painter and businessman. Yet his mother's demise and his youngsters' needs did not keep George in Arrow Rock. He sent Horace to live and study with Eliza's father in Columbia, and gave Eliza oversight of Clara. The little girl became as inveterate a traveler as her father. After numerous miscarriages, Eliza herself bore only one child, a son, after the Civil War had begun. George would name him James Rollins Bingham and call him "Rollins" as a perpetual reminder of the family's great friend and benefactor.

Although George's occupation as an artist-businessman kept him increasingly absent from Arrow Rock, his friends did not forget him. Among his chums was John Beauchamp Jones (1810-1866), today remembered as a once widely read novelist. Jones was Bingham's age and, like him, grew up on the Missouri frontier, much of the time in Arrow Rock, where he worked briefly as a storekeeper. From this experience came one of Jones's most popular novels, *Life and Adventures of a Country Merchant.*

Jones set the novel in Arrow Rock, although his sense of humor led him to call the village Venice. George Caleb Bingham appeared twice in the book, only once by name, but he obviously influenced Jones's political outlook. Bingham's actual appearance was part of Jones's depiction of life along the "mad Missouri" River. His descriptions were intended to be accurate, including steamboat explosions as well as citizens relieving themselves behind bushes. Jones has the hero of the novel, named Nap Wax, acclaim Bingham as the "Missouri artist." Nap Wax was much excited that Bingham intended to make the town on election day a subject for a painting. Every citizen was advised that they were likely to be in the picture—"me, too, with my potbelly," said Nap Wax. "I've seen the first sketch of it," Nap boasts, "and it'll be a famous picture." All the Arrow Rock businessmen appearing in it would find the experience "better than an advertisement."

It was on the subject of elections themselves that Jones demonstrated the influence of George Bingham, whose frequent political speeches were well known to the novelist. The author has

Nap speak admiringly of Bingham's style—which had shaped the novelist's own approach. "Oh, he'll put down every thing as it is. . . . It'll be as natural as life itself. He [Bingham] has the genius to do it."

It is in the closing pages of *Life and Adventures of a Country Merchant* that one can hear Bingham in one of his shouting moods when Jones, after looking back at the political antics he has described, speaks scornfully of the American system "which makes presidents of men who have no claims upon the people, and who are selected by an irresponsible few without previously consulting the will of the majority." The United States had become an "absurdity" for it was "no longer in accord with principles of democracy." Thus did John Beauchamp Jones echo passages of George Caleb Bingham's fiery stump speeches on behalf of the Whig party.

Like his friend Jones, George did not allow central Missouri to drop either from mind or from creative work. Perhaps no prominent American artist of his time used his talent with greater success in portraying life as it went on around him. In a half-dozen years after 1849, Bingham's canvases included examples of genre painting at its best, and these displayed political life in the critical manner that Jones bespoke in his novel. The three canvases making up Bingham's renowned election series were *Stump Speaking, The County Election,* and *The Verdict of the People.*

As George devoted himself to this project, he spent most of his time in New York City, where he resumed his relationship with the Art-Union. The organization offered what he considered good pay, and he could rely on it to see that his work was distributed around the nation. For a short time it proved an ideal situation. With Eliza, his bride, usually beside him, Bingham became amazingly productive. Not that George could entirely ignore politics. In a series of lengthy letters, he offered James Rollins his opinions on most of the day's public issues—and what George considered the intrigue-ridden party system's inability to deal with them. In March 1851, he advised Rollins that the Whigs needed "a frank avowal of our principles and a straight forward policy."

But now Bingham had begun to fear that duplicity was not limited to politics but was spoiling his valued relationship with the American Art-Union. The organization's managers, he reported to Rollins, were showing "gross favoritism" in what they paid artists for their canvases. Bingham's misgivings were well founded. The organization's records do show inexplicable and very large differences between what was paid to Bingham for his canvases and what some of the other artists received. While the executive committee of the Art-Union never offered George more than $350 for any of the twenty paintings he sold them, a few other artists received well over $1,000 more for their work. George began casting about for ways in which his canvases could be engraved and copies widely distributed under his own salesmanship.

Inequities of payment did not end Bingham's association with the Art-Union; he was offended in an area much more sensitive than his purse—his pride. The cause for George's indignation appeared in the December 1851 issue of the Art-Union's monthly *Bulletin*. This same organ just two years before had published the organization's official praise for Bingham's work, commendation that had helped greatly in establishing the artist's national repute. But the tone was just the reverse in December 1851 when the *Bulletin* printed a letter from an anonymous reader that spoke harshly of Bingham's work. The letter did not represent the view of the Art-Union itself, as the manager earnestly sought to remind the offended Bingham. But being so angry with the organization over the differential in payments, George refused to let it off the hook in this matter. Claiming that his professional ability had been impugned in pages of the *Bulletin*, Bingham announced he would sue the Art-Union for damaging his name.

The statement which so outraged the Missouri artist began when the unidentified letter writer took up the subject of "the development of nationality in American art," a process to which Bingham correctly believed his paintings had contributed significantly. The writer disagreed, however, claiming that another American genre painter, William Sydney Mount, was "the only

one of our figure painters who has thoroughly succeeded in delineating American life." And what about George Caleb Bingham? Conceding that George had made some "good studies" of western character, the writer dismissed these as "so entirely undisciplined yet mannered, and often mean in subject." Then came perhaps the cruelest cut—the contributor to the Art-Union's *Bulletin* contended that as a painter Bingham showed "such want of earnestness in repetitions of the same faces that they are hardly entitled to rank."

Although the Art-Union offered him space for a reply in a future issue, George decided to press his suit for damages. But the Art-Union had more serious problems than Bingham's wrath. While the artist fumed and talked to lawyers, the organization's system by which members won paintings through a drawing of names was found in 1852 to violate New York law. The Art-Union promptly went out of business, and George was left without a target for his indignation.

With the disappearance of the Art-Union also vanished its invaluable commercial assistance to artists. While some painters felt forsaken, Bingham knew exactly what he must do. He would enter the business field as his own manager. The result was four years of frenetic activity. While George's letters to James Rollins became much more numerous between 1852 and 1856, they suddenly had little to say about politics. Instead, George wrote mostly about his plans for financial success.

As he told Rollins, he intended to continue painting canvases depicting everyday life. This decision brought an economic challenge. To meet his family's expenses, George would have to realize as much or more money from these large works as he had from doing portraits. This meant that more money had to be squeezed out of his large canvases than would come from selling them one by one. Consequently, guided by what he had learned from watching the Art-Union distribute hundreds of lithograph copies, George set out to recruit his own engravers to carve onto stone such of his works as *County Election*, his main project in 1852. Numerous prints or etchings would then be

made from this plate for sale to persons that Bingham would have signed up as subscribers.

Ideally, this scheme required that the artist drum up sales by taking the original canvas on tour, exhibiting it before crowds that might assemble in towns and villages to gawk at it and then perhaps listen as George occasionally "lectured" to them. It was a technique urged by James Rollins but disliked by George who claimed it was "boring" for speaker and auditors. Still he was willing to try almost anything that might coax members of the audience to push forward, eager to order a copy to hang in their living rooms. The plan succeeded quite well, although Bingham learned that the price of becoming a businessman was the loss of much precious time for painting in his studio.

Yet another distraction was the exasperating task of choosing and then working with a studio that would make engravings of his oil paintings. It was from an engraving—a copy of a painting painstakingly cut into stone by the lithographer or engraver— that prints would be made for Bingham to peddle. Consequently, it was important that an excellent engraver be found. There were two lithography firms to whom George turned. One of these was operated by a Philadelphia engraver named John Sartain. The other choice was the French firm Goupil and Company, which maintained an office in New York City.

Bingham launched his business career on January 31, 1852, with a letter mailed from St. Louis to Goupil in which he described his troubles with the Art-Union and then announced his intent. "My *County Election* has excited more interest than any of my previous productions, and my friends here propose to raise a sum which will enable me to publish it, in superior style, upon a large scale." By publish, Bingham meant produce prints for sale.

But before a deal could be struck with Goupil, George traveled to Philadelphia where he was impressed by John Sartain's ability and also by the bargain price for which Sartain proposed to do the demanding work involved in copying *County Election*. Sartain claimed that he was lowering his usual charge because

he greatly admired Bingham's painting and coveted the chance to be its engraver. Much gratified, Bingham left the canvas with Sartain who pledged to finish the work promptly.

Eventually the Goupil firm would receive a share of Bingham's business, mainly by offering to do both the artistry of reproduction and the drudgery of sales and distribution. But George turned to Goupil only after the painstaking John Sartain had taken long past his own deadline to finish engraving *County Election*. Sartain's delay created an unforeseen problem for Bingham. Sartain needed the painting in his Philadelphia workshop, but the only way George could rouse interest around the country in purchasing copies of the forthcoming engraving was to display *County Election* for the crowds to see. The only alternative was to leave Sartain copying from the first canvas of *County Election* while Bingham painted a second one.

The second painting was nearly identical to the one in Sartain's studio. Furthermore, George gave it the same title—*County Election*. He saw no reason why he could not solicit subscriptions for copies of *County Election* number two, although purchasers would eventually receive prints from the engraving drawn by Sartain from the *County Election* that was first painted. With the second canvas completed, Bingham took it on tour beginning in the autumn of 1852, hoping to persuade many citizens to order copies.

Missourians received the first opportunity to sign up for prints of *County Election*. After considerable success among his neighbors, Bingham then moved further afield in the early spring of 1853, going initially to the New Orleans area so that he could reunite with his wife and daughter. The two had spent the winter with Eliza's brother seeking improved health under the Louisiana sun. In late spring the Binghams left New Orleans and headed for Kentucky. George visited many towns and villages, remaining in the Bluegrass State through the summer heat. Eliza and daughter Clara suffered with him.

In each locale, Bingham's sales strategy was much the same. He would have the canvas put on public display in a courthouse,

store window, or some other central building in the community. Meanwhile, he would see that word of his visit was spread around the county. As interested or merely curious individuals approached the painting, either George or his local agent would offer them an opportunity to own a fine piece of art. The public would then be invited to affix their signatures in a book listing their willingness to pay as subscribers to receive an engraving of *County Election*. No exact date for delivery could be promised as Sartain's labors went on and on.

From the outset, the tour was a triumph. A viewer in New Orleans was so captivated by the canvas that he wished to buy it outright, offering George twelve hundred dollars for it. The sum was too much for the artist to resist, and when the purchaser agreed that George could continue the tour with the canvas, George sold it on the spot. Enthusiasm for *County Election* owed much to a reviewer's comments published by the *New Orleans Daily Picayune:* "The picture is an admirable one, as every one will readily believe when we state the painter's name, G. C. Bingham." The critic said that Bingham was to the western region of America what William Sydney Mount was to the East—the prime "delineator of national customs and manners."

As word of the painting spread and Bingham arrived in Kentucky ("this most lovely land," he called it), the local papers were even more enthusiastic than those in Louisiana. One writer wondered whether any other artist could make a scene so wonderfully lifelike as Bingham had done. His work "has the full dignity and interest requisite for a great historical painting." Bingham was said to possess "extraordinary resources," able with merely a brush and "a little oil" to mirror nature. Small wonder then that Bingham picked up thirty-five subscribers in Louisville, and by the time he left Lexington for such Kentucky towns as Danville and Richmond, he had secured over a hundred. Most of these purchasers agreed to pay eight dollars upon delivery of their print. While these agreements were hardly binding, George was comfortable for he deemed his patrons to be "of the best and most reliable class of citizens."

Not everyone joined in praise for *County Election*, however. One letter to the paper in Lexington objected strenuously to Bingham's work. This critic complained that the artist obviously was mocking the cherished principles of the American republic by the way in which he portrayed many of the characters. Seeing drunkenness, gambling, and Africans pictured in *County Election*, the disgusted commentator charged Bingham was defaming the political process. He claimed he could not comprehend how patronage could be extended to this "mortifying" treatment of voting in America. The critic's conclusion: George Caleb Bingham had produced "worthless rubbish." The indignant writer evidently did not dissuade many subscribers.

Leaving Kentucky in early September 1853, Bingham made a successful stop in Cincinnati and then hastened on to Philadelphia where he implored Sartain to redouble his effort to complete the engraving. After all, George now had customers in Missouri, Louisiana, Kentucky, and Ohio waiting for their copies—and he was impatient to collect their payments. Subscribers rarely put any money down when they signed as willing to buy a print. George's plea brought a disheartening answer. Sartain discouraged any prospect of a prompt delivery. Although he assured George that the stone on which the engraving was being made would be capable of supporting up to twenty thousand prints, it would be many months before it was ready to do so. And then only twelve to fifteen impressions could be made each day.

Weary and dismayed, George went up to Goupil's New York office. The French company offered to buy the copyright for *County Election* and thereby claim the authority to sell all copies after the nearly thousand subscribers rounded up by George during his tour had received their prints. The artist would receive a royalty on each print the Goupil firm sold. George agreed to think about the proposition.

He quickly became inclined to accept Goupil's deal after distribution of the first prints finally began in the summer of 1854. It was then that Bingham found the art business entering its dreariest phase. He had to pay representatives to track down the

subscribers—by no means an easy task, secure payment from each—often another difficulty, and then finally turn over a print to each investor. An exasperated George soon threw up his hands and entered into the agreement with Goupil.

The firm began immediately to reap the financial reward from *County Election* while Bingham was freed to concentrate on painting the remaining two canvases in the election series. While the artist kept close watch on Goupil, he became increasingly aware that he had made a sound financial arrangement. Judging from the careful review of his association with Goupil that Bingham sent to James Rollins, both artist and distributor stood to make a good profit. What was perhaps more important, however, was George's acknowledgment to Rollins that his experience as a salesman had convinced him he was better off "producing rather than selling pictures."

Not that operating an art business had entirely distracted Bingham from his passion for politics. In June 1852, he took time from his frantic schedule to serve as a Missouri delegate to the Whig national convention held at Baltimore. Afterward, he reported to Rollins that "such a political tug was perhaps never witnessed before." For the disappointed Bingham, this meant that "men rather than principles furnished the controlling motive to the members of the Convention."

Bingham's pessimism deepened as the issue of extending slavery into the Kansas and Nebraska territories increasingly dominated the political scene after 1854. As he watched the "demagogues" led by Stephen A. Douglas of Illinois seize control of national affairs, George became downright disgusted. His dismay seems to have slipped onto his canvas as he painted the second of his great trilogy of election scenes. It was named *Stump Speaking*, although George first called it *County Canvass*. By November 1853, he believed he was proceeding well enough to show sketches of it to John Sartain in Philadelphia. Sartain's response was electrifying and greatly reassured George. The engraver said that while once he had thought Bingham would never be able to paint a canvas that would surpass the achievement of *County*

Election, he predicted that *Stump Speaking* would do just that.

Much encouraged but still weary from trying to sell prints of *County Election,* George changed his plan for *Stump Speaking.* He had intended to make it a large canvas that could be sold for a large sum to hang in a notable public place such as the capitol in Washington. But after listening to Sartain's praise, he decided to do with *Stump Speaking* as he had with *County Election*—have it engraved and prints made for sale to the public. Consequently, George negotiated a handsome contract with Goupil in Paris to do the engraving "in the most superior style." The terms were, in Bingham's opinion, "as favourable as any artist ever obtained from a publisher."

Bingham was saved the tedium of being a traveling salesman since Goupil had agreed to sell the prints, but he did not put the role of businessman behind him. He continued to haunt the studios of Goupil and Sartain, hoping to encourage both high quality and speed in their work, and lost time in his studio as the brushes and oils lay undisturbed. George also wrote to James Rollins recounting in minute detail the elaborate terms he was either seeking or had secured.

Thus occupied by painting, negotiating, and writing letters during 1854, Bingham lived pleasurably in Philadelphia, until he and his family took refuge from the summer heat by residing temporarily near the ocean on Cape May. There were hurried trips back to Missouri for George to plan the third and final painting in the election series, *The Verdict of the People.* He told Rollins that he intended it to be "a representation of the scene that takes place at the close of an exciting political contest just when the final result of the ballot is proclaimed from the stand of the judges." Such a painting would feature a "variety of expressions" that included "comically long faces," To achieve this, Bingham realized that he would need the sketches and notes he had made long before of the citizens he knew from around Arrow Rock. These figures were given places in all three of the election canvases, thereby creating what George perhaps sarcastically called a "gathering of the sovereigns." In designing *The Verdict of the*

People, he could not resist frequently adding another figure or face—as he reported to Rollins "a new head is continually popping up and demanding a place in the crowd."

From the autumn of 1854 to the summer of 1855, Bingham was able to apply himself almost entirely to painting. The result was astonishing, especially so since George acknowledged that during part of that time he suffered from "despondency" due to "the vexatious delays" in the sale of his election series. Even with the melancholy, however, George completed both *Stump Speaking* and *The Verdict of the People*. He did not widely display the latter, but he assured Rollins in June 1855 that all who had seen it "pronounce it the best of my work." The artist believed that it combined "more striking points than either of its predecessors."

Perhaps another reason for George's depressed moods was the realization that he had reached his mid-forties. It brought him moments of self-appraisal. At one point in a letter to James Rollins, he exhibited the exuberance of one who believes his work has led to artistic or literary excellence. On another occasion, Bingham confided to Rollins, "I am getting to be quite conceited," acknowledging that he even whispered to himself: "I am the greatest among all the disciples of the brush which my native land has yet produced." Once the election series was finished, George predicted, "I shall have laid the foundation of a fortune sufficient to meet my humble expectations, and place my little family beyond the reach of want, should I be taken away from them."

Such elation led Bingham to begin planning a residence in Paris after the election series was completed. By living in France, he anticipated overseeing firsthand the delicate process of engraving as the Goupil Company worked on the canvases. George even spoke of studying in the European art galleries and of doing more paintings featuring the men who worked along the Missouri River. He believed that James Rollins, who had become influential in the federal government, would be able to arrange an appointment for him in the American consular service, preferably in France or Italy, and he anticipated supporting himself and Eliza on the salary.

When no such appointment was forthcoming—and it would be hard to imagine the cantankerous and impatient Bingham succeeding as a diplomat—George decided to combine politics and art for his financial backing in Europe. This would come from painting huge portraits of George Washington and Thomas Jefferson to adorn walls of the Missouri capitol. Bingham was confident that his former colleagues in the legislature would agree to send him off to Europe with a generous financial commission. This time George was not disappointed by Jefferson City. He was elated when news arrived that Missouri's treasury would pay him thirty-five hundred dollars to portray Washington and Jefferson.

At first, the Binghams had hoped to leave for Europe in 1855 after George had completed *The Verdict of the People* in the spring. Their departure was postponed until late summer 1856 to allow the legislature to approve payment for Bingham's capitol portraits and also to permit the Goupil firm time to secure Europe's best engraver to work on the election paintings. Such artist-workmen were scarce. George spent the year edging back into the political scene.

He was drawn by the increasing furor over whether Kansas should enter the Union as a free or slave state. As Bingham had feared, this issue had grown until it threatened the Union. Increasingly, northerners were demanding that human bondage be limited to the original southern states while citizens in the South were loudly insisting that state and property rights meant that slavery could be established in the western territories. The politicians in Washington hoped to steer between these angry factions by announcing that the people who moved into the territories must decide the question for themselves. This policy was named "popular sovereignty."

Bingham, however, called the idea "squatter sovereignty," implying that the individuals who would make the choice between freedom and slavery were not likely to be serious settlers and reliable members of the body politic. He believed this type of frontiersmen could best be labeled "Border Ruffians."

Portrait of Thomas Jefferson (1857-1858). Bingham had learned
how other artists were making a living from commissions by
state legislatures or Congress. They painted larger-than-life por-
traits of famous Americans to be hung in legislative chambers or
on capitol walls. Bingham lobbied the Missouri legislature suc-
cessfully for subsidies to paint giant portraits of Thomas
Jefferson and George Washington. Besides his own financial
motives, he hoped that the presence of large likenesses of these
two founders of the Union would calm the anger in the legisla-
ture caused by the quarrel over slavery. After receiving the com-
mission Bingham took his family to Europe, where he completed
the paintings. They were lost in the capitol fire of 1911. *State
Historical Society of Missouri, Columbia*

Themes: The Rivers and the West

Commentary

Landscape with Cattle (1846)

George Caleb Bingham's reputation as a great painter rests mainly on his magnificent depictions of everyday life. His name calls up memories of his river series and his election scenes. Splendid as these achievements are, Bingham also merits acclaim as a landscape artist who sought to glorify the American West. In this respect, he displayed a debt to one of the most distinguished American artists of that day, Thomas Cole. Cole's untimely death in 1848, and the outpouring of national grief that followed, evidently spurred Bingham to renew his effort to paint scenes of the West he so loved. Bingham took particular pleasure in depicting agricultural settings. Many of his cattle scenes have disappeared, but the one shown here must have been among Bingham's finest. It was well received both in Missouri and New York. Later in life, Bingham returned to landscape work but never again showed the inspiration evident in his earlier efforts.

The Storm (1852-1853)

Bingham occasionally moved beyond tranquil rural or agricultural scenes to try a form called paintings of the sublime, which emphasized the power and grandeur of nature. *The Storm* was one of these efforts Bingham completed in the 1850s before he

left for Europe. He seems occasionally to have used the form while working in Germany but left it upon returning to the United States to face the fearful distractions of Civil War, particularly those in Missouri. In the late 1860s, when his work as a state official was mostly finished, Bingham lived on and off in Colorado, seeking a cure for a persistent lung ailment. The Rocky Mountain scenes around him renewed his interest in portraying the sublime, but neither his mood nor his capacity led to successful results. By then, as Bingham himself admitted, it was best that he be content with painting portraits.

Fishing on the Mississippi (1850)

Viewers have come to expect that Bingham's acclaimed river paintings will feature men and boats in various scenes of lively activity. A charming exception to this is *Fishing on the Mississippi*. Here Bingham's figures appear passive as they stare at their lines in the water. Their deceptively quiet posture contrasts dramatically with the ominous sky looming behind them. Indeed, the splendid colors used for the sky are considered by some art historians as marking a milestone in Bingham's development as an artist. Consequently, it appears evident that the sky—and not the figures nor even the river itself—is Bingham's principal subject in *Fishing on the Mississippi*.

A secondary theme may lie in the river's calming effect upon the humans who have been lulled into ignoring the violent weather that will soon be upon them. Bingham introduces active and apparently wiser boatmen by a kind of footnote when he places several figures in the far distance frantically struggling with their flatboat as they search for a haven from the coming storm, leaving the fishermen to await their fate in ignorance.

Thus, considering how different this canvas is from Bingham's other river scenes, some of which are shown hereafter as illustrations for this book, it may be significant that he chose the Missis-

sippi rather than his beloved Missouri River as the setting for
this interesting exception to his more familiar presentations of
the river.

Fur Traders Descending the Missouri (1845)

Perhaps because it is prominently displayed by New York City's
Metropolitan Museum of Art, this canvas may be Bingham's
best-known work. With it, he reached maturity as a painter and
found an aim for his artistic efforts. He intended to use his talent
and his knowledge of the American West to encourage eastern-
ers and even Europeans to appreciate both the beauty and the
spirit in the region where his beloved Missouri was central.
Bingham planned to do this by portraying two great rivers, the
Missouri and the Mississippi, as well as the bustle of life they
fostered. Art historians have various interpretations of
Bingham's intent with *Fur Traders*. One critic fancied the picture
of a French trapper and his half-breed son spoke of youth and
age gliding through time with the river being a metaphor for life.
Another, equally romantic viewpoint contends that the bear cub
tied to the prow of the boat is meant to symbolize the wilderness
being tamed by mankind. Those critics more realistically
inclined have preferred to debate whether the creature in the
prow might actually be a cat instead of a tiny bear. None of this
speculation, however, has distracted most viewers from admir-
ing Bingham's achievement with color. It was the first of many
triumphs in his portrayal of the rivers he loved.

Raftsmen Playing Cards (1847)

This may be Bingham's ultimate display of the great western
river as a paradise of nature's beauty and humanity's blissful life
when embraced by the river. The artist, however, took pains to

include in the picture a snag peeping up in the center of the river. This reminds the viewer that none of us know what dangers lurk even at the surface of life. The cardplayers, it seems, are oblivious to the menace, with the pole man peering far ahead, beyond any immediate threat. He painted *Raftsmen* two years after *Fur Traders Descending the Missouri,* and Bingham's colors here remain somewhat muted and hesitant, compared to the more vibrant tones he soon would employ. As an artist, he was groping his way, and on his trips east he learned by studying the work of other fine painters of nature, particularly those who focused on the Hudson River region.

Watching the Cargo (1849)

This canvas shows Bingham's more confident use of color and suggests that he was now at least hinting that a story was present in a picture. Danger appears to lurk in Bingham's usually soothing river setting. Not even Bingham could persist in picturing western river life as amiable. Even so, the three figures shown here seem comfortable as they guard cargo taken from a steamboat that has run aground in the distance. A close examination of the canvas reveals a small boat continuing to unload the hapless steamboat. Thus, Bingham concedes that all was not invariably well on the Missouri River. But his growth as an artist was progressing nicely. In the short time since Bingham had painted *Raftsmen Playing Cards,* he had come to qualify as a master colorist.

The Wood-Boat (1850)

Like *Fur Traders,* the figures in this canvas seem both near and far from civilization. Bingham depicts them through the same marvelous use of light—in this case it is dawn or twilight—and

color. In *The Wood-Boat,* however, his figures appear much more poetic, so that viewers might think of the three ages of human-kind. The persons in this scene are not being moved through time by the river's current; they are masters of the river. They appear calmly to await the arrival of a steamboat that will need the load of wood they intend to sell it. Bingham may be saying that life can be calm in the West since the river brings all of human needs together for fulfillment.

Jolly Flatboatmen in Port (1857)

Bingham lived in Germany when he painted this picture. During that time, he was also painting the Washington and Jefferson portraits for the Missouri legislature, but the assignment did not occupy all of his time. Although he was far from his Missouri haunts, he was still beside a great river—the Rhine, on which the town of Düsseldorf was located. Encouraged by such a familiar setting and also the wishes of other painters in the Düsseldorf Academy, George undertook one more study of flatboatmen. It proved to be perhaps the most famous of the series, full of color and life. Here the familiar flatboatmen are shown in an early-morning frolic as they await a new day's work at the St. Louis wharf along the Mississippi. This canvas reflects two important developments in Bingham's style and work: the influence of the European artists whose paintings had shown Bingham how to resolve problems of composition and figure arrangement, and the increasingly mature technique, first displayed in the election painting, that was further defining his vision.

Landscape with Cattle

Saint Louis Art Museum, bequest of Mrs. Chester Harding Krum

The Storm
Wadsworth Atheneum, Hartford, Conn., gift of Henry E. Schnakenberg

Fishing on the Mississippi, 1850

Nelson-Atkins Museum of Art, Kansas City, Mo. (purchase of Nelson Trust), 33-4/4, photo by Robert Newcombe

Fur Traders Descending the Missouri

Metropolitan Museum of Art, Morris K. Jesup Fund, 1933 (33.61), photograph © 1988 Metropolitan Museum of Art

Raftsmen Playing Cards

Saint Louis Art Museum, bequest of Ezra H. Linley, by exchange

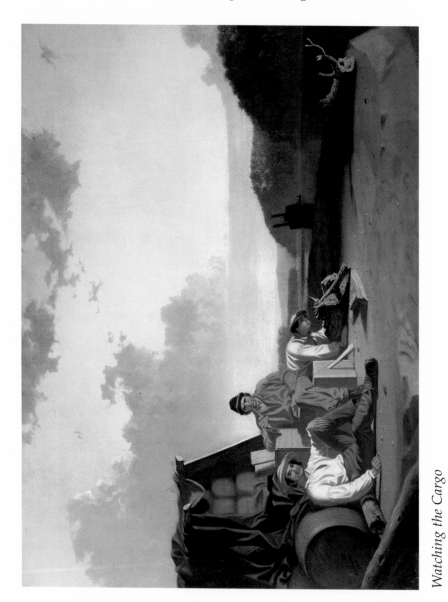

Watching the Cargo
State Historical Society of Missouri, Columbia

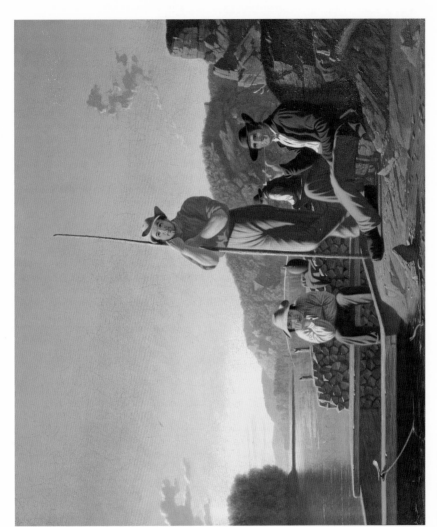

The Wood-Boat
Saint Louis Art Museum, museum purchase

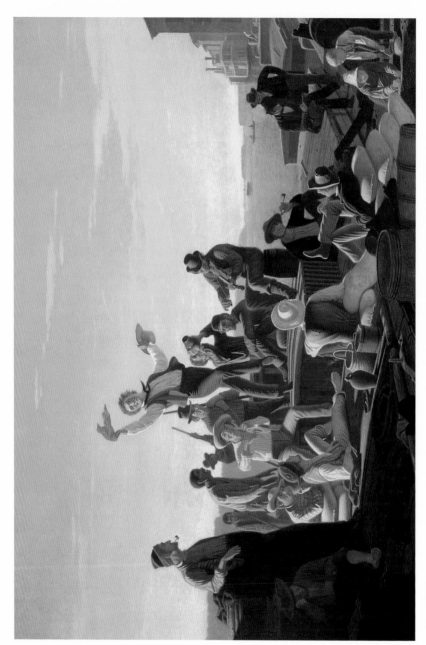

Jolly Flatboatmen in Port
Saint Louis Art Museum, museum purchase

Like most Missourians, Bingham was much troubled by the way in which mobs were being hustled across Missouri's western border into the Kansas Territory. There, presumably by fair means or foul, these gangs ultimately would make the territory into either a slave or free state. This scene both fascinated and alarmed Bingham.

Kansas had to be much on George's mind during the summer of 1855 as he waited to leave for Paris. He was painting portraits in Independence, Missouri, a town located on the very edge of the trouble, not far from the border. This vantage point afforded Bingham a close view of how the supporters of slavery were trying by violence to take command of Kansas. The result convinced him "that Slavery is doomed, and that Providence is determined to use its brutalized champions as the instruments of its overthrow." He announced that once he returned from Europe he would begin another series of political paintings. The subject would be squatter sovereignty, which Bingham deemed no more than "organized rowdyism."

When George and Eliza finally left for Paris in midsummer 1856, he was no longer a Whig. Instead, he had become an avowed supporter of the new Republican party and its candidate for president in 1856, John Charles Frémont. The switch was encouraged by the fact that Frémont was the son-in-law of Thomas H. Benton, whom George had come almost to revere because of the former senator's stout defense of the Union. Senator Benton himself did not support the candidacy of his son-in-law, choosing to back James Buchanan, the Democrat. Bingham's conversion to being a "black Republican," was owed in part to a visit he made to Boston, the seat of abolitionism, shortly before he sailed for Europe. He was there to copy the heads from Gilbert Stuart's portraits of Jefferson and Washington to guide his own work in Paris.

On August 14, 1856, George, Eliza, and daughter Clara embarked for France. They crossed on the *Vigo*, one of the early steam ships, with the artist feeling quite carefree. He had entrusted James Rollins with every detail of the family's finan-

cial affairs. Thus reassured, George used much of the voyage to review what he had accomplished in the past ten years. Although he conceded that his finest achievement had been the election series, George was nearly as pleased when he recalled the paintings that featured life on the Missouri and Mississippi rivers—*The Concealed Enemy, Captured by the Indians, Raftmen Playing Cards, Watching the Cargo, The Wood Boat, Fishing on the Mississippi, Flatboatmen by Night,* and others. As he drew closer to Europe, George recalled the numerous landscapes and cattle studies he had completed, along with what seem to us to have been no end of portraits. This record of achievement pleased him. And well it might, but he could not foresee that his greatest days as an artist were by then behind him, nor could he know that his finest hours in politics would begin when he returned to Missouri in 1859.

This prospect was far from George's mind when he and his family arrived in Paris on September 1, 1856. He turned at once to the business of collaborating with Goupil in reproducing and selling the last two canvases from his election series. In spare moments, he remembered his commitment to the Missouri legislature to paint giant—twelve feet high—portraits of Washington and Jefferson. George soon encountered serious problems with both the engraving and the painting.

Goupil had yet to locate qualified engravers, leaving George with no work to oversee. As for painting, he found that Paris offered few rooms with ceilings high enough and lighting bright enough for what he considered acceptable studio conditions. Nor did Paris have anything comparable to the boardinghouses of St. Louis and Washington. Bingham wrote James Rollins that while an apartment might be rented, meals must be taken at cafés or brought in by caterers. All of this threatened to lift the Binghams' cost of living in Paris to one hundred dollars per month. It was not simply the cost of living, however, that encouraged George and Eliza to leave Paris. As Missourians they were country folk at heart. Even though they had lived for a time in Philadelphia and New York City, they were more accustomed to

small, quiet places like Arrow Rock and Columbia. The enormous size of Paris and their inability to speak French left them overwhelmed. George called the city "this great centre of luxury, Art, and fashion."

He was also taken aback by what he saw in Paris's Louvre, which housed one of the world's great art collections. He was confronted by a wide range of styles, or "schools," that were new to him, including early modernism. Bingham feared that in the presence of these influences, he would have difficulty retaining a clear perception of nature. He confessed he was shocked by "the various guises in which she [nature] is here portrayed." While he conceded that there was much of value to be learned in the Louvre, it would require a long time, he wrote Rollins in early September 1856, "before I can be able properly to appreciate the treasures which it contains."

Bingham's next letter to Rollins was mailed two months later, dispatched from the German town of Düsseldorf. The letter was nothing less than jubilant. It also breathed a spirit of relief. Clearly, the Binghams were elated by their decision to leave Paris. Now, in a comparatively small German town where English seemed to be widely spoken, they felt at home. George called Düsseldorf a village, although it contained perhaps thirty thousand citizens. Large trees lined quiet roads; there were none of the "dashing vehicles such as encumber the gay avenues of Paris, causing perpetual alarm to the humble pedestrian." Best of all, perhaps, was a park where Eliza and daughter Clara could walk in comfort. This was now especially helpful since Eliza's health had been continuously weakened by a succession of miscarriages.

Perhaps the principal reason for George's move to Düsseldorf was that a successful genre painter whom he sought to emulate, Emanuel Gottlieb Leutze, had already established himself there. Leutze's presence made Düsseldorf very attractive. Born in 1816, Leutze had emigrated from Germany to the United States as a youth with his parents. After making a good beginning as a painter, he returned to Germany around 1839 to become one of

the leading figures in the Düsseldorf Academy. In 1859 he returned to America to accept a commission from Congress for one of his major works: *Westward the Course of Empire,* the mural that continues to adorn the Capitol. Leutze died in 1868 in Washington.

It was in Düsseldorf, however, that Leutze painted his most famous work, *Washington Crossing the Delaware.* This widely beloved canvas hangs in New York's Metropolitan Museum where it serves as the finest example of Leutze's great success in using historical scenes as a subject. He completed it in 1851, several years before Bingham appeared in Düsseldorf, by which time Leutze's style had helped to shape the character of painting done by artists of the Düsseldorf school—firm drawing, careful detail, and generous use of color, all of which appealed to Bingham. Another reason George felt drawn to Düsseldorf was that four other artists besides Leutze had come from the United States to work in the town.

Bingham and Leutze immediately became close friends, and George received valuable advice on how best to work as an artist in Europe. George was amazed at the ease with which he had found a spacious and inexpensive apartment to rent. Soon, he located a studio nearby with dimensions ideal for the huge Jefferson and Washington portraits. He was so pleased that he began assuring James Rollins "that if a painter cannot support himself in Düsseldorf, or any large city in Germany or Italy, he has not merit to entitle him to support anywhere."

George went on to explain how compatible he found the artistic style that prevailed in Düsseldorf. It flourished "by its own inherent vitality." He advised Rollins that the German approach to art was not servile to "'the old masters,' taking instead a direct resort to nature for the truths it employs." The result were paintings that could be deemed "simple" and "rational." They were characterized by a freshness that Bingham claimed brought such "vigor and truth" as to delight viewers of both "common understanding" and "the highest cultivation." In short, George fancied the German style had been his own all along.

As if to prove this point—and quite possibly to impress his new colleague, Emanuel Leutze—George produced a painting from his American style. He did this as he waited for the space and equipment he had chosen in Düsseldorf to become available. Bingham was confident that the best way to introduce his work to Leutze and the circle of Düsseldorf artists was by depicting a scene from the great rivers of his native Missouri. Unsurprisingly, the canvas he began was tentatively entitled "Life on the Mississippi." He thought that by working on the banks of the Rhine River amid congenial German surroundings, he would produce a river painting "far ahead of any work of that class which I have yet undertaken."

By the time the canvas was completed, however, Bingham had created more than a study of nature. Once again, he had involved the boatmen of Missouri, for he had brought to Europe many of his sketches depicting these figures. He used these for *The Jolly Flatboatmen in Port*, a handsome variation of one of his 1846 canvases. And who can say? Perhaps a touch of homesickness prompted Bingham to use some of his precious time in Germany for work in his well-known style and on a familiar scene. Whatever the reason, the result was highly successful.

By mid-1857, George was considering an indefinite stay abroad. When his son Horace, who had been left in Missouri to study with Eliza's father, failed to be admitted as a student at West Point, a disappointed George instructed the son to join the family in Germany. After Horace arrived in Düsseldorf, he took his place beside Clara as a student in classes where they anticipated a swift mastery of several continental languages. The pair succeeded to an admirable extent. Not so for their father's hope to have his family enjoy an extended stay abroad.

For this plan George again required the help of James Rollins, whose career as an antislavery Whig was receiving national attention. Counting on his friend's numerous contacts, Bingham implored Rollins to secure for him a diplomat's post appropriate for an artist. As he explained to Rollins with a touching absence of guile, his artistic progress would benefit immeasurably from

a State Department post "where the pay greatly exceeds the labor." Would Rollins please arrange such a job for him in Rome? George inquired.

Alas, both Bingham's and Rollins's ambitions were pinned to the election of the Republican presidential candidate, John Charles Frémont, but Frémont was defeated by Democrat James Buchanan in 1856. Bingham predicted that this result would lead to a crisis in American politics. Abruptly, he shelved his plan to remain in Europe indefinitely and resolved instead to return soon to America. His letters to Rollins now talked mostly of the slavery controversy and its threat to the Union. He begged for news of the political climate in Missouri. Should it come to open fighting, George swore to be on hand to serve the Union.

Then, with hope for a diplomatic assignment gone, Bingham gave his attention to the commission awarded him by the Missouri legislature—to paint portraits of George Washington and Thomas Jefferson on canvases eight feet by twelve feet in size. For Bingham, this was as much a business as an artistic undertaking. He saw it in political and commercial terms, and he hoped there would be more such commissions. Before the Washington and Jefferson projects were finished in July 1858, George implored Rollins to arrange that he be invited to paint two more giant portraits—of Andrew Jackson and Henry Clay—to hang in Missouri's capitol.

While Rollins succeeded in getting the commission for George, the Jackson and Clay portraits were not completed until 1860. The Binghams returned from Germany in September 1859, although George had briefly reappeared in America, primarily because he would not trust others to oversee shipment of the Washington and Jefferson portraits to Jefferson City. He was particularly concerned that the delicate procedure of framing and hanging the canvases should be completed properly—something he contended only he could do.

Also, George believed another bit of business required his presence in Missouri. This was collecting payment by the legislature for the cost of the portraits' frames—nearly five hundred

dollars. George had ordered frames made in Germany, which he claimed would be of better quality and cheaper than any found in Missouri. With Rollins's help, Bingham persuaded the legislature, which finally passed a bill in the amount for the frames, to the artist's considerable relief.

George stayed in Missouri during the winter and spring of 1859. He kept busy not only overseeing the hanging of the Jefferson and Washington portraits, but also lobbying a reluctant legislature for money to paint likenesses of Clay and Jackson. It was politically astute of George to pair the two, since Jackson was hero of the Democrat party and Clay of the Whigs. After the commission was finally approved, George took this success to indicate "that my devotion to art for so many years may at length receive its reward."

There were other signs of Bingham's reward. Outside Jefferson City and across Missouri, he was widely in demand as a portrait painter. During the first months of 1859, when his interests in the capitol could spare him, George passed through towns between St. Louis and Kansas City collecting handsome fees from painting likenesses of the state's prosperous citizens. While he did so, he listened to talk of the grim political scene in Missouri, where civil war seemed ready to break out.

George's brief reappearance to do business in Missouri had one amusing feature. He had proudly brought with him from Germany a piece of handiwork made by his fourteen-year-old daughter, Clara. It was a likeness of George Washington done in needlepoint, which Bingham solemnly presented to the Missouri House of Representatives. Since that body consisted of gentlemen, they ordered that Clara Bingham's gift be hung behind the Speaker's chair—and the representatives then began to discuss what sort of gratitude they should extend to the young lady—at taxpayers' expense, of course.

Since George was hanging around the capitol at the time, he sought quietly to help the house determine his daughter's reward. He whispered to friends in the chamber that a suitable gift would be a "ladies work box" made to order in Paris. George

advised that it should contain "apartments for writing, drawing, and sewing implements," and that it "have elegantly engraved upon it the Arms of our State, the name of the Governor, the President of the Senate, and the Speaker of the House of Representatives." Having given this counsel, Bingham stopped short of influencing the amount of money that should be appropriated for Clara Bingham's reward. But he took care not to withdraw entirely. Instead, he urged his friends in the house to seek guidance from the widely respected Rollins. And lest Rollins be uncertain about the amount, George quietly pointed out that five hundred dollars would be enough for the work box. The ever-helpful Bingham also volunteered to take a bank draft back to Europe for payment to the Paris firm that would create the magnificent gift for his daughter.

George's return to Germany was, however, less than happy. Shortly before embarking in June 1859, he learned that Eliza had suffered another miscarriage. After he rejoined his family, they received devastating news from Kansas City of the death of Eliza's father, Robert Thomas. The Thomas family had moved to western Missouri in 1853 where Thomas briefly served as president of William Jewell College before residing in Kansas City. The sad tidings arrived as George and Eliza were on a trip through Belgium seeking another school for Clara and Horace. Eliza was so stricken by her father's death that George felt he had no choice but to take her immediately back to Missouri.

Thus ended the Bingham family's expectation of an extended stay in Europe. Plans were put aside for visits to London, Italy, and Switzerland, as well as for more time in Paris—where Goupil's engravings of the election series still remained incomplete. They were eventually finished, and the resulting prints were widely distributed. Bingham's return to America marked the end of his finest artistic achievements. He would live another twenty years during which his modest output displayed nothing of the superior quality seen in his election and boatmen series. Bingham devoted those years to another calling—serving Missouri as a statesman.

Chapter Six

An Angry Statesman

Well before he returned to Missouri in 1859, George Bingham was paying close attention to the deepening sectional crisis in the United States. He already knew that the most ominous rumblings in the nation arose from the region along the Missouri-Kansas border. In and around Missouri's Jackson County, warfare had broken out openly between bands of guerrillas, pitting those who favored making slavery legal in Kansas against those who opposed the expansion of bondage. Since Eliza Bingham's widowed mother and other relatives now lived in Kansas City, George's own interest had begun to shift to that part of Missouri. The deep divisions in the state, and particularly the devastating savagery in Jackson County, combined to fuel George's anger, anger that would burn for the next ten years.

During that decade, public affairs and particularly a term as state treasurer would permit Bingham little opportunity for his work as an artist. The one memorable canvas he painted during that time, *Order No. 11*, was mainly an expression of his outrage at conditions in western Missouri during the Civil War. It displayed little of the artistic talent he had applied to numerous paintings in the previous twenty years. He also painted portraits of political and military figures, including Andrew Jackson and Henry Clay, to decorate the state capitol. These canvases, destroyed by fire in 1911, grew out of the artist's determination to make a political statement—although payment from the public treasury certainly was another motive.

As soon as the Binghams had resettled in Missouri late in 1859, George joined James Rollins and other political associates in trying to make sure the approaching presidential election would bring an agreement that would calm slaveholding states and claims that the South—and even Missouri—might secede from the Union. One strategy he and James Rollins contrived entailed an elaborate ceremony for the unveiling of Bingham's giant portrait of Andrew Jackson in Missouri's capitol. Since "Old Hickory," who was beloved in Missouri, had been a champion of Union, to honor his memory thus might strengthen the state's opposition to disunion, or so George hoped.

For this scheme to work, George had to complete the Jackson canvas. He made a brief visit to Washington, D.C., in January 1860 hoping to refresh his knowledge of the former president's appearance by copying Thomas Sully's painting of Jackson's head, which was owned by Samuel Phillips Lee, a cousin of Robert E. Lee's. Hearing gossip in the capital, Bingham quickly sensed the strain between North and South. He wrote to James Rollins, who would be elected to the Congress that November, that the House of Representatives sought to choose a speaker who would reassure the slave states. But he was dubious whether any accord could last until the fall campaign.

As election time approached, Bingham and his family were living in Kansas City while George finished his portrait of Jackson. He had already completed a giant likeness of Henry Clay. As he worked, Bingham tried to be optimistic. "I look forward to the election of Lincoln," he admitted to James Rollins. He believed that Lincoln's administration "will allay the present Sectional strife by demonstrating to the people of the Southern States that the large majority of their Northern brethren are willing to concede to them every thing to which they are clearly entitled under the Constitution."

What happened, of course, was quite the opposite. Lincoln may narrowly have won the national vote, but he ran a poor fourth in Missouri where Stephen A. Douglas, a Democrat with southern leanings, took first place ahead of the tickets led by John Bell and

by John Breckenridge. Bingham himself had decided the logical choice was to vote for the Constitutional Union party's nominees, John Bell and Edward Everett. He had no wish to force emancipation upon the South. His overriding concern, one shared by the Bell-Everett ticket, was to discover a constitutional basis on which to preserve the Union. George did take care, however, to circulate word that if the Bell-Everett ticket did not win, he would be delighted to see Lincoln elected—he still yearned for a diplomat's post.

After Lincoln's victory, George continued to be mildly optimistic, particularly about Missouri remaining in the Union. His talks with folks in Kansas City and Independence led him to conclude that, in spite of Jackson County's support for slavery, the county would agree that Missouri should not follow South Carolina and others in seceding from the United States. If only a pro-Union majority could be elected to the legislature, Bingham predicted that most Missourians would agree "to keep our state in its true position of Loyalty to the Union." Better yet, said Bingham, perhaps some constitutional juggling in Washington might permit the remainder of the Union to allow only South Carolina to slink off to live by herself.

Bingham's hope for sectional accommodation was soon crushed. Despite Lincoln's calming words, clamor for secession took on new intensity in the southern states. Ruefully, George predicted to James Rollins that a war between slave and free states would be inevitable if the new administration insisted that federal laws be enforced everywhere. And Bingham had to agree that such firmness was what the nation needed.

As the crisis advanced, George displayed his capacities for political and legal understanding that had once brought some friends to urge him to pursue a career in law. His letters to Rollins contained ingenious ideas about the nature of federalism that were in some ways as striking in behalf of the national government as John C. Calhoun's theories supporting state rights. Unfortunately, this talent had to compete against George's worst qualities—his quick temper and his impatience with opposing views.

With the secession crisis worsening, George began to speak with cutting sarcasm about southerners. "These people," he told his friend Rollins, "have always been averse to hearing more than one side of the question at a time." Not only did a southerner seem incapable of weighing the "Pros and Cons," but he was "as averse to intellectual as to physical labor." Once George's scorn toward the South warmed, he could be scathing. Southerners, he remarked to Rollins, "will cheer the demagogue who affirms that one South Carolinian is an overmatch for twenty Yankees, and lynch whomever might venture an argument to prove the contrary."

Again writing to Rollins, who was preparing to take his seat in Congress, Bingham accused citizens of the South, and particularly those in South Carolina, of becoming "thoroughly imbued with the idea that they are the greatest people in the world, have the greatest country in the world, and that the Federal Government is all that prevents a full manifestation of these facts." Just let southerners live outside the Union for awhile, George predicted, and "they will come to a more correct conclusion."

It was not surprising, therefore, that Bingham's impatience with those who disagreed with his support of federal supremacy got the best of him in public. Unfortunately, this occurred during the speechmaking on January 8, 1861, that accompanied the unveiling of his portraits of Andrew Jackson and Henry Clay in Missouri's capitol. George came to Jefferson City still smarting from another dismaying result of the 1860 election, the choice of Claiborne Fox Jackson as Missouri's governor. Not only was Jackson a longtime enemy of Bingham's, but he had become a secessionist. The possibility that Jackson would call on Missouri to leave the Union (which he soon did) obviously weighed heavily on George when, after the canvases were hung and much admired, he was invited to say a few words.

At once he was in trouble, for he chose to quote at length from President Andrew Jackson's 1832 summons for all citizens to join in putting down any state that might disobey federal law. Jackson had issued this proclamation in response to South

Carolina's nullification of federal tariff duties and threat to secede from the Union. The air in the Missouri House chamber grew even more combustible as George went on to challenge persons who opposed the federal government, which included many members of his audience. He accused them of being traitors, so it was predictable that a newspaper account of the event described Bingham's remarks as a "violent coercion speech." There was no hope of restoring good humor in the capitol when, after a legislator tangled verbally with George, Bingham called his critic "a low dirty dog."

What had been planned as a ceremony of dedication brought down a storm of controversy, due mostly to the behavior of the house's honored guest and former member, George Caleb Bingham. Legislative indignation over the artist's behavior prompted talk of refusing to pay him for the paintings. George replied to this by threatening to take the portraits of Clay and Jackson to Illinois to present to the president-elect, Abraham Lincoln. He had not lost hope for a diplomatic appointment.

Ultimately, George received his money from the legislature, but only after he had carried the Clay and Jackson portraits to St. Louis where they enjoyed a highly successful temporary display amidst the strong Union sentiment in that city. While in St. Louis, Bingham joined other foes of secession such as James Rollins and Frank Blair in devising a strategy for Missouri if war should break out between North and South. Bingham was among the most pugnacious members of the group—"Our country is full of traitors," he reminded Rollins. "I think it is our duty to denounce them as such every where, and if fight comes in consequence, I am for no backing out."

But as civil conflict moved closer, a family matter abruptly pulled George away from Missouri for some weeks. It was the worst possible time to depart the scene for he was determined to keep pushing his Republican comrades to "present me in a sufficiently favorable manner to the President." George never knew when to quit. He believed that his strident call for preserving the Union should earn from Lincoln "an honorable and lucrative

appointment . . . either in France or Italy." Nevertheless, he had no choice but to leave when word arrived that his bachelor brother, Matthias Bingham, had died on January 12, 1861, in Houston, Texas.

Matthias had been a prominent figure in the creation of the Republic of Texas, fighting alongside Sam Houston for independence and thereafter rising to become quartermaster general of the Republic. Matthias was prosperous when he died, possessing perhaps five thousand acres free and clear. Nevertheless, Bingham suspected that the estate was in jeopardy because of machinations by "a gentleman professing to have been an old friend of my brother." Matthias's heirs were George, his sister, Amanda, and their brother, Henry.

On March 6, 1861, with a hundred dollars borrowed from the ever-generous James Rollins, George boarded a steamboat headed for New Orleans. He left wishing that President Lincoln had been more severe in his inaugural message. "I am tired of submission to traitors. If they will force a war I am for giving them enough of it." From New Orleans, he traveled to Houston where he intended to apply his knack for practicing law to save the bequest of his brother from what George feared was "a gross fraud." Although he found that nothing shady was threatening the estate, Bingham discovered a more serious menace. Texas's decision to secede meant that Matthias's wealth had abruptly become located in the Confederate States of America, a foreign nation, which prevented the estate's immediate settlement. It was 1873 before George could return to oversee distribution of Matthias's legacies.

While Bingham was in Texas, Missouri seemed to move in the direction of Union as he had hoped. When the new governor, Claiborne Fox Jackson, insisted that a state convention be held to decide whether Missouri should join the new Confederate States of America, the retiring governor, Robert M. Stewart, earned Bingham's gratitude by urging citizens not to support secession. His plea was heeded, and to Governor Jackson's surprise, not a single delegate favoring secession was elected to the convention

held during February and March 1861 in St. Louis. Even in the few counties where a slave economy predominated, the prevailing sentiment remained for Union.

While the convention had stood against secession, as a delighted Bingham discovered on returning from Texas, what occurred afterward nearly ruined Missouri. Despite the convention's clear statement, Governor Jackson hoped to push the government in Jefferson City into the ranks of the Confederacy and prepared to use force against federal troops in Missouri if necessary. After Jackson received some backing from Jefferson Davis, president of the Confederacy, he ordered all state militia commanders to convene camps where their troops could gather. General Daniel Frost established Camp Jackson, named for the governor, near the U.S. arsenal in St. Louis but was forced by Nathaniel Lyon's federal troops to surrender.

The capture of Camp Jackson by the Union side took place in May 1861. Soon thereafter, Governor Jackson and state leaders failed to reach agreement with federal spokesmen at the Planter's House in St. Louis; the governor issued a proclamation vowing to defend Missouri against the federal aggressors. On June 15, General Lyon occupied the capitol in Jefferson City on behalf of the Union. After Governor Jackson and his supporters failed to defeat federal troops in another engagement at Boonville, Jackson and members of his administration fled South, establishing a Missouri government in exile. In December 1862, when Jackson, who had returned to try to take back Missouri, died, his followers retreated to what they claimed was Missouri's Confederate capital in Texas.

Meanwhile, Missouri remained in the Union under a provisional administration in Jefferson City. It was presided over by the cautious Governor Hamilton Gamble, whose principal challenge was persistent trouble caused by Southern guerrilla forces. Particularly in the central and western parts of Missouri, the guerrillas' favorite tactic was to pretend to be quiet citizens during the day, but to slink out at night to attack their neighbors.

From his home in Independence, Bingham watched this

tragedy unfold, all the while fuming at "the damnable treachery of our Governor [Jackson] and his infamous satellites." While his letters to Rollins spoke mostly of the tension and violence within Jackson County and its neighbors, George was compelled once again to make a personal plea. He reported to Rollins that he and his family were in serious financial need. "Art is far below every thing else in such times as these."

He assured James Rollins, now a congressman allied with Republican leaders such as Frank Blair and Edward Bates: "You see I do not aspire at present to the highest places however high my merits. A position even so humble as that of assistant door-keeper would satisfy me."

By late June 1861, however, the turmoil in Jackson County had become so savage that Bingham announced he would under no circumstances leave the county. Kansas City's loyalty as a Union town brought threats by Rebel forces led by Sterling Price. Although George was fifty years of age, he prepared for a fight by enlisting as a private in the U.S. Army. His friends, however, were determined to rescue the famed artist from so lowly and dangerous a station. When the mayor of Kansas City, Robert T. Van Horn, created a battalion of Home Guards, Bingham was elected captain of Company C.

After a time, Kansas City became comparatively safe so that George felt secure enough to resume writing to James Rollins begging for "a more agreeable situation in the Consular or diplomatic service." His supporters provided far more handsomely than the artist could have envisioned. His good fortune was made possible when the incumbent state treasurer, A. W. Morrison, refused to take the oath of loyalty to the federal government. Morrison was dismissed, and Governor Gamble appointed George Caleb Bingham. The artist served in this office from January 1862 until he returned to Jackson County in November 1865.

Of those years there are few details. It is certain that Bingham painted some portraits and that he also sought consent for more artistic projects from the legislature. Certainly the happiest event

of the war years for George was the birth of a son on September 21, 1861. In early June, George had begun hinting to James Rollins that Eliza was again with child. More important, he indicated that for the first time they had reasonable hope she would escape miscarriage. When the baby was safely delivered, the couple gave thanks to a physician in Düsseldorf whose advice, they claimed, had led to a sound pregnancy. George was especially delighted for he had long wished to have a son whom he could christen James Rollins Bingham. From the start, the child was called Rollins.

The very few surviving letters George wrote from the treasurer's office show him to be hardworking, but not thrilled with the assignment. His impatience was caused in part by Governor Gamble's conciliatory attitude toward all factions. The governor sought to accommodate demands of those citizens sympathizing with the South, while George continued to view them as traitors. Although he lived in the comparative safety of the state capital, George could not ignore the violence persisting in his home countryside, the area along the border between Missouri and Kansas. It tormented him to know that bloodshed and destruction continued to reign in Jackson County and in neighboring Cass, Bates, Platte, and Vernon counties.

The horrors in these counties had begun before the Civil War, as the struggle involving the future of Kansas Territory as slave or free intensified. Those years saw the appearance in Kansas of such violent figures as John Brown, who felt justified in slaying Missouri whites in order to loosen the chains of their slaves. The war brought a new crop of villains who sought to defend the Southern cause. Men such as William Quantrill, "Bloody Bill" Anderson, and Cole Younger and their gangs rode into Kansas to avenge Missourians who had suffered from raids by such invaders from Kansas as Jim Lane, who—amazingly enough— was also serving as one of Kansas's U.S. senators. Among the worst of the border raids was Quantrill's attack on the town of Lawrence on August 21, 1863. Quantrill's raiders made no secret of their intent to kill every male old enough to bear arms, and

they came close to doing so, slaughtering 150 men and burning 185 buildings.

Missourians, including Bingham, watched as the Lincoln administration bowed to demands from Kansas that such behavior as Quantrill's must be halted. What distressed citizens of Jackson County was that Lincoln's orders were to be carried out by Brig. General Thomas Ewing, the federal commander of the military district around Kansas City. Himself a Kansan, and formerly chief justice of the state's supreme court, Ewing was so concerned about the suffering in his state caused by gangs out of western Missouri that he went to what Bingham and others considered outrageous lengths to punish Missouri. This was the way George viewed Ewing's General Order No. 11, issued on August 25, 1863, four days after Quantrill's dreadful raid on Lawrence.

This proclamation was intended to eliminate the supply base for forces such as Quantrill's, but it did so with breathtaking severity. Ewing decreed that all farm inhabitants in the border counties abandon their property within a fortnight and leave the district. He then added insult to injury by directing that cavalry troops from Kansas come to Missouri and help enforce the harsh regulation. These troops included Charles R. "Doc" Jennison, a person whom George Bingham particularly loathed and against whom he published courageous public denunciations. Jennison and his radical followers, disguised as cavalrymen, turned Jackson and other counties into a charred wasteland.

Bitterness and hatred caused by Ewing's order prevailed in Missouri long after the end of the war. George's rage was deepened by a personal grudge he held against Ewing because the general had commandeered a building in Kansas City owned by Eliza Bingham's widowed mother, Elvira Thomas. Located at 1425 Grand Avenue as one of a row, it had become home to George and Eliza when they returned from Germany and before George became state treasurer—at which point the Binghams had moved to Jefferson City, taking Widow Thomas with them. Until then, George had used as a studio a third floor he had added to the Thomas residence.

Ewing had turned the vacant house into a prison for women who were allegedly collaborating with guerrillas. Five of these women were killed on August 13, 1863, when the house collapsed. Some said the accident was caused when several of Ewing's troops, who were quartered in the house next door, undertook to enlarge rooms by removing walls and tampering with support beams. As part of the row house design, the beams were connected to beams in the Thomas/Bingham house, so what affected one also affected the other. But as was pointed out at the time, the weight of the third floor that George had added to his mother-in-law's residence could well have caused the building to fall in on the women.

Bingham never acknowledged any fault. Instead, he professed to be outraged by this event and pained that innocent women had died. When General Ewing showed little interest in helping Elvira Thomas recover damages for loss of property, the artist came to despise the commanding officer. He told James Rollins that while Ewing would treat even a horse thief from Kansas very cordially, the general "was not capable of doing justice to an honest Missourian." As soon as his incumbency as state treasurer ended, Bingham vowed that he would make General Ewing rue the day he had ever set foot in Jackson County, let alone issued Order No. 11.

In 1864, as his term as treasurer was closing, George and Eliza Bingham bought a house and nineteen surrounding acres in battered Jackson County. The property was located on what was then the southern edge of Independence but is now near the town's center where George's residence has been designated an historic site. As such, it is one of the most handsome structures in Independence, standing as a testimony to George's determination to surround himself with elegance.

Here, he and Eliza lived for five years, and here also Bingham set to work on three canvases. Two of them were not extraordinary. One was a memorial to General Nathaniel Lyon, depicting him astride his horse as he led troops into the Battle of Wilson's Creek on August 10, 1861. Lyon was killed in the battle, leaving

Missouri's wartime legislature wishing to commemorate him with a portrait to hang in the capitol. George was paid three thousand dollars for the Lyon painting after he finished it in March 1867, most of the money having been raised by subscription. The second canvas, a small picture called *Major Dean in Jail,* was actually a political statement reflecting Bingham's indignation at the harsh treatment of moderates by Missouri's postwar government.

The third painting, begun in 1865, has become one of Bingham's most famous. It expressed his fury over General Ewing's treatment of Missourians. Entitled *Martial Law or Order No. 11,* the work has something of a legend about it. As the story goes, when word reached Bingham while he was state treasurer in Jefferson City that General Ewing had issued the decree exiling nearly all residents of Jackson County and its surroundings, Bingham acted at once. He hastened to Kansas City to confront Ewing and demand an explanation. The general replied that he had acted from military necessity. To this, Bingham pointed out the human misery sure to ensue. When Ewing refused to rescind Order No. 11, Bingham is said to have told the officer: "I will make you infamous with pen and brush as far as I am able."

Whether the exchange occurred or not, George's anger had not cooled when he began work on *Order No. 11,* and he clearly designed the painting as an assault on Ewing. He depicted the officer and others in the act of carrying out the infamous order. Two versions of the scene were completed in November 1868 with George intending them as an argument against the evils of martial law and as a weapon to hinder the career of the detested Thomas Ewing.

One version of the canvas was sent to Philadelphia to be engraved by John Sartain. The other traveled with George as he went about the region denouncing General Ewing and all his evil works—and, just as important, taking orders from those who wished to purchase a print of *Order No. 11* after Sartain's studio had finished engraving it.

Bingham's tour had the marks of a political crusade. Wherever

an audience would gather to listen, he assailed the harsh policies of what had become known as the radical wing of the Republican party in Missouri and elsewhere. Much as George had deplored what he deemed the traitorous behavior of the secessionists, he opposed postwar punitive treatment of those who had supported the South but now wished to take their places as voting citizens of Missouri.

On those occasions when Bingham was asked to explain his purpose in painting *Order No. 11*, he was careful not to hint at any personal vendetta against General Ewing. Instead, he preached from a loftier text, as when he replied to an inquiry from the Reverend R. S. Johnson. George informed Johnson that the painting sought only to teach that "the tendencies of military power are anti-republican and despotic, and that to preserve Liberty and secure its blessings, the supremacy of Civil Authority must be carefully maintained." In time, and with James Rollins's encouragement, George doubled the title of the painting, making it *Martial Law or Order No. 11*. Earlier, he had considered calling it simply *Civil War*. Nowadays, given the controversial career of the painting and George's claims for it, it is usually known as *Order No. 11*.

The painting is nearer propaganda than distinguished art. When Bingham wrote a description intended to publicize *Order No. 11*, he found it difficult to disguise the emotion that had compelled him to paint the work. George's description reveals almost at once how passion rather than cogent reason had dominated his work: "The principal group in the foreground of the picture chiefly consists of a venerable patriarch and his family who have just been ejected from their dwelling, which is about to be committed to the flames. A daughter clings to the defiant form of the old man, imploring him to temper his language so as not to incur the vengeance of the brutal assassin [General Ewing]. . . . Another daughter is on her knees before this wretch vainly endeavoring to awaken some emotion of humanity in his callous breast."

George's description of *Order No. 11* continued in this florid tone as he pointed out that "a married son lies weltering in his

blood, his young wife bending in agony over his lifeless body." The artist spoke of how an "aged mother has fallen into a swoon" and of how in the background of the canvas could be seen "the myrmidons of Kansas, aided by their criminal allies in Federal uniform" and all "busily engaged in the work of pillage." As these evildoers took their plunder westward toward Kansas, Bingham urged the viewer of the canvas to note the citizens of Jackson County, "a melancholy procession of dejected and impoverished refugees fleeing from their desolated homes." In this fashion, Bingham asserted, was "the military edict thus cruelly enforced"—not against rebels or criminals, but on innocent citizens.

If Bingham had hoped to raise controversy with his angry painting, he was not disappointed. His critics insisted that the work of an artist, as that of all good men, should be to strive, as one journalist put it, "to heal all the bitternesses of the past, and learn to forget its harsh features." For several years thereafter, George rashly replied to such judgments, often playing into the hands of those who insisted he was overbalanced and out of control. He hardly helped his cause by repeatedly insisting that the purpose of *Order No. 11* was to "hand over to eternal infamy the perpetrators and defenders of outrages which scarcely find a parallel in the annals of the most barbarous ages." Most of the time, those who objected that Bingham was using art for propaganda purposes easily had the best of the argument. George himself went so far as to acknowledge publicly that by painting *Order No. 11*, he intended to "keep alive popular indignation."

The most colorful evidence of how George was carried away by anger in doing *Order No. 11* was his personal pursuit of Thomas Ewing when the latter began a political career after the war. Until he died in 1879 George used every opportunity to resurrect the story of Order No. 11 and to elaborate on the excesses perpetrated under it. But he had another reason for pursuing Ewing—the collapse of the house in Kansas City, the structure atop which the artist had added a studio. George continued to insist that Ewing had allowed his soldiers to remodel an adjacent

house with fatal results for the women imprisoned in the Thomas property.

After the war, Bingham experienced much difficulty when he sought compensation from the federal government for this damage to his property, and he blamed both damage and delay on Ewing. When the latter was elected to Congress from Ohio, Bingham followed him to Washington in 1878, exclaiming that the public should know the truth about the new representative from Ohio. He also thought he might make progress in his campaign for financial restitution if he collaborated with Ewing's foes on Capitol Hill.

Bingham's obsessive pursuit of Ewing was one of the tragic features of the artist's last difficult years. After George's death, Ewing was asked for his opinion about the Missouri artist. His reply was remarkable for its gentleness. Bingham, he said, was a man of the highest ideals but with so little understanding of the necessities of war "that before he would commandeer a mule or a load of corn from a farmer in the line of his march, he would first have to consult the constitution to see that he was within the law." Ewing evidently was too much of a gentleman to point out that Bingham had never admitted how, late in 1863, the orders in Number 11 had been entirely rescinded, and all loyal citizens of Jackson County had been welcomed back to their homes—or what was left of them—by early in 1864.

The struggle with Ewing was certainly not the only challenge that George met as a result of his determination to make the tragedy of Order No. 11 forever memorable. Because of the painting, the burdens of managing the business side of art once again weighed heavily on him. The strain began to tell on his health and on his family's well-being. What should have been a satisfying close to a life of extraordinary achievement became, instead, a time of unrelenting frustration.

Chapter Seven

Final Frustrations

In May of 1870, Bingham sold his residence in Independence and took Eliza and Rollins to live in Kansas City. Why he did so is not clear, but one reason must have grown from his controversial canvas, *Order No. 11*. After his anger, born of wartime, began to cool, George recognized that he still needed to make art into a business. Consequently, he had to gain more from *Order No. 11* than simply settle a score with the detested General Thomas Ewing. Bingham realized that to secure greater income, he had to move to Kansas City, which by 1870 had outdistanced Independence as a center for commerce and transport. But even this progress never made the town entirely satisfactory to Bingham. Three years after switching to Kansas City, he seriously considered removing to New York City, which he acknowledged as the national center for art in all its forms.

Nevertheless, the Binghams remained in Missouri. Politics once again worked its magic on George, who began to listen closely as friends talked of his running for governor or a seat in Congress. He was pleased by the encouragement, but when deadlines for filing approached, he regularly postponed any active candidacy, usually because he realized the business of art needed his attention.

Indeed, art had become a much more serious enterprise for Bingham when, in 1871, he fulfilled his ambition to be genuinely a man of commerce. With James Rollins's aid, the artist created a Kansas City firm called "George C. Bingham and Company."

Kansas City scene in 1872. Bingham resided in Kansas City the last nine years of his life. This scene of Kansas City's bustling Walnut Street area would have been very familiar to the artist. He chose Kansas City mainly because of its business advantages. There it was easier for Bingham to sell prints of his paintings, particularly of *Order No. 11*. *Jackson County [Mo.] Historical Society Archives*

This step would mean no small amount of frustration in George's final decade of life.

Ironically, one cause of these difficulties was George's success in taking orders for prints of *Order No. 11*. Unfortunately, Bingham and Company had blundered in assigning the task of making the engraving to John Sartain. Sartain might have been one of the best engravers in America, but his firm rarely came close to meeting a deadline. This tormented George after he had spent much of 1870 and 1871 exhibiting the traveling canvas of *Order No. 11* and taking orders for copies. It was bad enough that these customers had to be offered apologies instead of prints. But for George, there was the even more distressing discovery

that no copies were available to ship to citizens in Ohio who might thereby have been inspired to vote against Ewing in his first campaign for office.

Sartain's tardiness also allowed George to change the title of the painting. Fortunately, the cumbersome result did not stick. But for the rest of Bingham's life, *Order No. 11* became—(believe it or not!)—*Desolation of Border Counties of Missouri by Military Orders Issued by Brig. Gen. Ewing of the Federal Army, Aug. 25, 1863*. This change, Bingham hoped, would make the painting's point clearer at a time when Congress frequently debated ways of combating the Ku Klux Klan. One means proposed by Congress would be to invoke martial law, which of course Bingham believed would unleash one of a republic's most dangerous enemies. *Order No. 11* sought to display the terrible results of martial law in Jackson County.

As demand for reproductions of *Order No. 11* had grown louder, and Bingham's frustration greater, by the end of 1871, George decided that he must go to Philadelphia to see for himself the cause of Sartain's delay. So annoyed had Bingham become that he speculated General Ewing might have paid Sartain to slow the work or even to destroy the plate. George called it "a slight suspicion in my mind." Although he soon realized there was no basis for such fears, George still believed that his presence in Philadelphia might at least encourage Sartain and his staff to bestir themselves.

Consequently, he presented himself at Sartain's studio just before Christmas 1871 for a stay that proved longer than he had planned. Bingham found himself very comfortable, having accepted an invitation from the Sartain family to reside with them during his stay in town. While life in Philadelphia was very pleasant, nothing speeded work in the engraving studio, even with Bingham peering over the shoulders of Sartain and his staff. Finally, to ease his frustration, George began to make his own corrections on the plate, an experience that taught him much about the art, and brought his admission that the work of Sartain and his staff was highly satisfactory, even if it crept at a snail's pace.

Not until late spring of 1872 did Bingham return to Missouri. He traveled happily for he was carrying a supply of prints of *Order No. 11* to Kansas City. He also brought with him more scathing newspaper attacks on Thomas Ewing that he had written to occupy himself during his months in Philadelphia. Editors in Missouri and Ohio appeared delighted to encourage the controversy between the artist and the general, for whenever assaults by Bingham were published, Ewing's supporters replied immediately with their own newspaper letters—which of course elicited a response from the perpetually outraged artist.

It was disappointing enough for George that this exchange seemed not to harm Ewing's career. More distressing for him, however, was that sales of *Order No. 11* prints began to lag. Bingham and James Rollins, the project's financial backer, tried to console each other when income from the prints did not pay even the cost of the engraving. In part, this was due to a slump in the national economy that began in 1873 and also to Bingham's declining health. He had been advised to leave selling prints to others and spend time in Colorado where the wholesome mountain air seemed to relieve his severe cough.

Whether in Colorado or Kansas City, George now had to worry over how he could repay the faithful James Rollins for his contribution to the costly engraving work ordered by George C. Bingham and Company from Sartain. There was also a second investor, R. B. Price, a leading citizen of Columbia, Missouri, and friend of Bingham's. Rollins and Price had put up five thousand dollars to be paid to John Sartain. For their investment the pair received a joint interest in the venture. To ease George's fretfulness, Rollins bought Price's share in the investment. In turn, George presented Rollins with one of the two original versions of *Order No. 11.*

For that version, Bingham took a tablecloth and painted *Order No. 11,* as his friend R. B. Price of Columbia watched. The painting now adorns the fine collection of Bingham's work owned by the State Historical Society of Missouri and is usually on display in the society's gallery in Columbia. The painting deserves to be

viewed if only to see an image that could cause so much furor in an artist's career.

Absorbed as he was by worry over sales of *Order No. 11* during the 1870s, Bingham did not allow business entirely to smother his interest in politics. This required that he try to stay committed to both business and public affairs while his health steadily weakened and his painting suffered. His best work after 1870 was in portraits; his imagination faltered when he attempted landscapes. These were usually painted in Colorado when he searched for relief from what he called his "weakness in the chest." From time to time, he sought to revive his once-lucrative partnership between politics and art by proposing to the Missouri legislature or to Congress that he should undertake historical paintings in exchange for financial support.

George finally thought he had such an agreement with the Missouri legislature, but the painting was never completed, due mainly to Bingham's temper. The proposed canvas was to depict General Andrew Jackson submitting to the civil authorities in New Orleans. George had long wished to paint such a scene, and he was especially eager to do so after his experience with General Ewing. The artist was eager to show the world that even the great Andrew Jackson had once put aside military authority in deference to civil law. But as Bingham began the painting, he learned that the Missouri legislature, in voting to support his work, had added a condition—it had to approve the picture before George would receive payment.

"This is no compliment," Bingham sneered. The rebuff infuriated him, for he considered himself still to be the best painter in his field. As a result, George grew impatient with Missouri for a time. He began to call it "my adopted State" and said he would take his depiction of Andrew Jackson to "my native state of Virginia." He expressed confidence that the Old Dominion's legislature would buy without hesitation any painting he offered for display in Virginia's public buildings. While no painting ever went to Virginia as a result of George's irritation with Missouri, his native state did eventually acquire one of his works. After

Bingham's early painting *Going to Market* hung unrecognized for decades in a Kansas City mortuary, it was eventually discovered and brought to Richmond by the Virginia Museum of Art.

How George's feelings came to be hurt by Missouri's legislature, as well as stories of other events in the artist's final years, can only be pieced together through Bingham's letters to James S. Rollins. George wrote endlessly to his friend about matters personal and public, even admitting that he was confused by the public issues dominating the time. "It is somewhat difficult for one now to see clearly his political duty." Among George's concerns was the social impact from the enfranchisement of persons who had once been slaves in Missouri. George said that giving African Americans the vote brought "a new era" into the state. The education of these "new sovereigns" was essential, he wrote. Actually, George showed little interest in the well-being of the freed blacks—he had sold all of his slaves before the Civil War had begun.

A regular topic in Bingham's letters was his steady decline in health. In 1873, he was speaking of how his cough "hung on with tenacity" and that he suffered much pain. Excursions to the Colorado mountains would sometimes briefly restore him, bringing the boast that he now walked "from four to five miles every day." Even more startling, George once claimed that he had been so restored in health that he planned to establish a studio in New York City where he foresaw a high demand for portraits. This move to the East, George announced, was the idea of Joseph Hutchison, M.D., the brother of Bingham's first wife, Elizabeth Hutchison.

The move to New York never came. Instead many of Bingham's letters to Rollins were hastily written from small towns in Missouri and beyond, for despite medical advice George could not resist going on the road frequently to hawk prints of *Order No. 11.* One of the most amusing of his letters was mailed in September 1873 from the Louisville Exposition in which Bingham described to Rollins how the display of *Order No. 11* drew large crowds. Even though the canvas "attracts great attention,"

George complained there were few orders. Because the crowd "constantly presses" around, "I cannot distinguish such persons who would most likely purchase an Engraving." Even worse, "the noise from the machinery [on display] and the constant buzz of innumerable tongues renders it almost impossible for me to engage in a conversation with any person without a strained effort."

Given his persistent cough and lung problems, the disappointing experience in Louisville persuaded Bingham finally to become more serious about hiring others to travel the countryside for his company. At the close of the Kentucky stay, he confessed to Rollins that his health, restored in Colorado, had again collapsed. "I had a severe chill and subsequent fever two days ago." The illness persisted, even to the point of intruding on his brief career as head of the Kansas City Metropolitan Police Commission in the late spring and summer of 1874.

The legislature had established the commission a few months earlier, and Bingham had been appointed its head by the governor, Charles H. Hardin, who hoped the artist would stand firm against the waywardness of local appointees. George certainly sought to do so. His service began with Binghamlike vigor when, at the commission's first meeting, he ordered every gambling house in Kansas City suppressed, with the result that several hundred high rollers were turned out onto the streets. But George paid a high price, for as he reported to Rollins, "the next day I was confined to my bed and there remained for more than two weeks." Finally, he arose long enough on a Saturday to order that the city's police chief make certain that every saloon was closed on the next day, Sunday. It was done as ordered, but not to popular acclaim.

Bingham's career as a crusading commissioner "raised a howl," as he put it, with the result that a "large meeting of saloon keepers and demagogues" issued a protest against the commission's policies. Bingham replied to the complaint with another stern statement, which, he told Rollins, "is regarded as the end of the controversy and all is now running smoothly." All this excite-

ment took place in May 1874. Still, the tension remained, as did the cough and the weakness in Bingham's lungs. His condition left him without the energy to carry forward his intent to clean up Kansas City or fight the "demagogues."

These circumstances alarmed the watchful James Rollins as well as Governor Charles Hardin. They agreed that a change was necessary in order to rescue the health of Commissioner Bingham and to restore some quiet to Kansas City. In January 1875, George was named by Hardin to be the state's adjutant general. Bingham was delighted, for the post gave him an even more important cause to champion. His new office allowed him to begin a campaign to secure compensation for the many Missourians who had claims against the federal government arising from wartime destruction of their property or from bills that the United States purportedly owed them. The fact that Bingham and his relatives were among those holding such claims helped to invigorate his work as adjutant general.

Relying on others to continue the sales of *Order No. 11* prints, George moved temporarily to Jefferson City. From there, he arranged extended stays in Washington, D.C., where he lobbied in behalf of congressional bills that would authorize compensation for Missourians. It was frustrating work, but Bingham kept it his main concern for the nearly two years he served as adjutant general—a dignity that permitted him thereafter to be hailed by the public and the press as "General Bingham."

During 1875 and 1876, "General Bingham" made frequent appearances before committees of the U.S. House and Senate in behalf of damages sought by his fellow Missourians. With his aggressive style and his skill as a public speaker, George was a colorful witness—and a successful one, for many Missouri claimants received payment. It was a heady experience, and one that tempted Bingham to consider seeking even higher political posts. He assured Rollins, who had begun pushing him to run for governor of Missouri, that "I would accept the office if properly tendered"—he meant by the call of the people. Yet George knew very well how the game of politics was played, so he

urged Rollins to begin "arousing a hopeful public sentiment in my favor."

As Bingham thought more about remaining in public life, he realized that he would rather sit in Congress than be governor of Missouri. Writing from Washington to Rollins in August 1876, he called his chances of being sent to Congress better than those of being elected governor. "I think I could strike a chord or two which would at least arouse the honest sentiment of the honest portion of the people of my district in my favor." After discovering he would have serious competition for the seat in Congress, however, George veered back to his interest in becoming governor. If and when he ran, he promised Rollins "I will immediately make public my position in regard to important matters which concern our state. I will denounce rings, clicks [cliques], and political combinations of every kind for selfish purposes, and declare war against corruption whether Democratic or Republican."

Such inspiring thoughts led George to conclude: "I have lost all party feeling." He inquired of Rollins whether this spirit might make him an even more attractive candidate for governor or Congress. "The times require a man who *has* enemies,—a man who is cordially hated by all the scoundrels who infest our public offices and fatten upon public spoils." As he wrote these words, perhaps the self-defeating idealism of what he was saying dawned on him. Soon afterward, George abruptly cited his recurring health problems as good reason to contemplate retiring from the political arena. At the end of June 1876, as the close of his term as adjutant general approached, he told Rollins: "Age is creeping upon me and I am beginning to feel its effects. My throat and cough trouble me more than usual this summer." He spoke of intending to reside during the winters in Florida or California. Such a change might secure for him "a little longer lease on life."

While the change to a warmer climate never went beyond just talk, Bingham was serious when he spoke of leaving public life. At the close of 1876, he slowly backed away from politics. "By pursuing my art profession as in the more happy period of my

Themes: Politics and History

Commentary

Canvassing for a Vote (1851-1852)

This painting and the three to follow were intended by Bingham as a series depicting a free society in its most important endeavor —making decisions about its own well-being. He portrayed individuals as they considered public issues and then went on to choose persons who were to carry out the electoral majority's wishes. Known as his election series, the canvases were painted after Bingham himself had fought for and won an electorate's confidence. In *Canvassing for a Vote* he pictures a basic moment in the democratic process—citizens considering the views of a candidate who seeks their vote. This lofty artistic endeavor was not, however, as dull as it may sound. Bingham filled the canvas with a variety of figures whose physical differences and behavior make the election drama both amusing and fascinating. While *Canvassing for a Vote* offers few figures, each one becomes an intriguing character study. We wonder if they are persuaded, skeptical, or simply grateful for the candidate's willingness to amuse them on a lovely summer day. Then there is the distracted gentleman who peers into a window. And, of course, one of Bingham's favorite actors in his genre studies, a dog, here seems utterly indifferent to this enactment of democracy.

Stump Speaking (1850-1851)

Bingham enjoyed using the likenesses of his friends and even his political enemies in his election canvases. He also frequently used the town of Arrow Rock as the backdrop. Legend claims that *Canvassing for a Vote* was set in front of the tavern. Here, in *Stump Speaking,* the actual locale may be less certain, but the figures are quite readily identified—and certainly the point or purpose of the painting is clear. It is to present another idealized moment in the enactment of democracy. Citizens from all walks of life are shown assembled to hear speeches by candidates. A "stump-speakin'" was the homely way Bingham's contemporaries designated such an event, and it allowed Bingham's sly humor to be at work. For instance, two dogs circle and sniff each other, as the Whig and Democratic parties were doing when Bingham was painting in the 1840s. Some citizens are shown perhaps more asleep than lost in thought. A latecomer, on his feet, could be another of the inebriates Bingham invariably included in these scenes. On the whole, however, the gathering is giving the speaker a thoughtful hearing. And the speaker is none other than Eramus Darwin Sappington, the foe Bingham twice faced in running for the legislature. In the background of the canvas Bingham portrays himself carefully taking notes as Sappington speaks. This crafty strategy allowed him to be pictured in quiet, decorous obscurity, while two of the orator's close kinsmen (and powerful Democrats) command either side of the canvas. Behind Sappington and beside Bingham sits the imposing figure of Meredith Miles Marmaduke, a recent governor of Missouri and brother-in-law of the orator. Then, seated in the front row and listening admiringly is Claiborne Fox Jackson, another brother-in-law. With his splendid hat, Jackson looks every bit a future governor, as he would become in 1861-1862. He was also one of the foes Bingham most detested. Consequently, it must have given Bingham much private amusement and satisfaction to depict himself in seeming humble insignificance—even though a Whig—while his Democrat foes are pic-

tured proudly dominating an election they were to lose. Bingham received the most votes in both 1846 and 1848, although the Democratic majority in the house denied him the seat in 1846.

The County Election (1852)

This delightful work merits careful study. Indeed, close inspection is needed to appreciate its subtle—and not-so-subtle—portraits of the behavior of individuals in a crowd gathered at a polling place on election day. The scene has the main street of Arrow Rock as background with the citizenry assembled before the courthouse. This structure is a somewhat glamorized version of the old Saline County courthouse, which still stands in present-day Arrow Rock. Among the nearly sixty figures portrayed, Bingham put himself in the center, seated on the bottom step of the courthouse and sketching as two onlookers watch. Some students have said that Bingham placed himself twice in the scene, the other instance being on the far right where a figure is seated and reading a Whig newspaper. Once again, the artist gives his Democratic foes the prominence. He places Governor Marmaduke at the top of the stairs as election judge administering the oath to a voter who has removed his hat and states his vote aloud. Just behind the voter and tipping his hat while presenting his card to the next citizen planning to vote is Bingham's opponent, Erasmus Darwin Sappington. The crowd includes many faces seen in other Bingham paintings. All of them are male. Numerous figures are seen conversing in earnest as they strive to make a point about the issues or the candidates. But what is startling for a canvas that might be expected to show only frontier democracy's nobler aspects is Bingham's emphasis on the presence of strong drink. A keg of hard cider stands in the left corner, while a black man refills the glass of a jolly chap who is leaning back in his chair with the glow of someone who has

consumed more than enough. On the far right is a participant in the electoral process who has drunk himself into a stupor. But there is an even more pointed admonition against mixing liquor and an election in two figures Bingham places near the center of the canvas. There they seem in a spotlight—one of the fellows is holding up his helpless inebriated companion while peering worriedly at the many steps up which he must lug his buddy as the two of them try to vote.

In this complex scene with its brilliant arrangement of many fascinating figures, Bingham seems to remind the viewer that democracy in action necessarily must embrace the solemn and the sordid, the thoughtful and the capricious. And since Bingham often took a cynical view of politics, he might well be warning that the thoughtful, judicious aspect of voting could readily be lost amidst the fawning candidates who present cards at the very moment of decision or by voters too drunk to clamber up before the judge. Thus, perhaps Bingham meant to attach disquieting meaning to the inscription on a banner fluttering high above the judge. It proclaims "The Will of the People the Supreme Law."

The Verdict of the People (1854-1855)

Many of the faces appearing in this lively scene will be remembered from Bingham's earlier election canvases or even the river series. On the right side of this scene, the artist places the same dancing chap who had been cavorting on a riverboat. Clearly, Bingham relied heavily on his drawings of men and boys in numerous poses; many of those characters appear in this painting, which is intended to celebrate the people's voice—as shown in the tabulation of their votes. And a celebration it certainly appears to be. Bingham goes so far as to include the ladies, although he keeps them securely beyond the reach of politics, which in those days was meant to be a man's province. Given

Bingham's professed veneration for the fairer sex, it is surely a deliberate tribute to this separation when Bingham places the women on a porch as seen on the upper right corner of the canvas. There they can be adored as they stand far above the emotional scene literally beneath them. And it is quite an uproar that the women are watching. Bingham painted the scene at a time when voting and popular decisions were particularly in the national mind as Congress debated whether slavery could expand into territories such as Kansas, next door to Missouri. Congress ducked the issue by creating "popular sovereignty," which allowed the male citizens of a territory to make the choice between accepting slavery or prohibiting it. In this painting as well as in his heart, Bingham often worried whether a frontier electorate could make such a decision responsibly. A look at the detail in *The Verdict of the People* makes Bingham's uneasiness evident.

Daniel Boone Escorting Settlers through the Cumberland Gap (1851-1852)

In portraying the Boone party, Bingham moved beyond his earlier emphasis on the unique and lively nature of the West with its rivermen, trappers, and Indians. Painting in the 1850s, Bingham was painfully aware of the deepening division between North and South. Consequently, he shifted his interest to topics with historical appeal, choosing scenes that might arouse a sense of national unity, such as portraits of legends and depictions of customs that rekindled pride in a free and ever-growing country. Bingham knew that Americans were enthralled by stories surrounding Daniel Boone and his decision to leave the eastern region and take his family and fellow settlers into Kentucky. It was a move with which Bingham empathized, for his own family had left Virginia for Missouri, although the move occurred many years after Boone's march through the awesome

scenes of Cumberland Gap, as here depicted. Bingham's enthusiasm for the dream of American national growth was such that five years after finishing the Boone canvas, he was lobbying the Missouri legislature to commission him to paint large portraits of two great nation builders, George Washington and Thomas Jefferson. Although he needed the fee the commission would bring, he also wanted the portraits to hang in the state capitol as inspiration for his fellow Missourians.

Portrait of John Quincy Adams (1844-1850)

Bingham admired no public figure more than he did John Quincy Adams. The former president was a congressman during the time Bingham and his family lived in Washington, D.C. Like Adams, Bingham was a Whig of strong opinions, and when Adams fought almost alone to defend the right of slavery's foes to petition Congress, Bingham, although a slave owner himself, supported Adams energetically. There is a legend that a friendship grew between Adams and the artist from Missouri after Bingham began to share studio space in the Capitol with another painter who was a cousin of Adams's. The latter supposedly had the habit of dropping by the studio for conversation, talk that often turned to discussions of the Bible. This was a subject about which both Adams and Bingham considered themselves expert. In 1844, Bingham painted this first portrait of Adams, now in the collection of the National Portrait Gallery, Smithsonian Institution. The second was done in 1850, two years after the former president died in the Speaker's Chamber in the Capitol. Owned by the Detroit Museum of Art, it was begun during the great mourning in the North for Adams. Bingham was determined to show his political hero as aged perhaps, but still defiant—a posture Bingham would seek to emulate in his last years.

Order No. 11 (1865-1868)

While this painting is among Bingham's best-remembered, it is far from his best work. Indeed, it may be said that its creation arose mainly from the artist's weaknesses. Bingham painted *Order No. 11* out of anger and a desire for vengeance against Thomas Ewing, the federal army general and Ohio politician who, during the Civil War, had ordered the evacuation of much of western Missouri. The artist aimed to have *Order No. 11*, which was finished after the end of the Civil War, rouse indignation and controversy. He claimed that it depicted the evils sure to result if martial law was allowed to prevail and run amok, as it had in western Missouri, Bingham contended, under "that wretch," as he called General Ewing. Lithographic prints of *Order No. 11* sold well and widely in the late 1860s and early '70s as Bingham traveled extensively displaying the painting and telling its story. Whether his audiences were more impressed by the personal vehemence and outrage exhibited by Bingham than by the painting itself is an intriguing question.

Photo of the graves of Bingham, his wife, Mattie Lykins Bingham, and Johnston Lykins

Bingham died in Kansas City on July 7, 1879. His widow, Mattie, attended to all matters arising from the artist's estate, including the auction of many paintings that were stacked in his studio. Mattie's most memorable deed on behalf of her late husband, however, was the selection and arrangement of his burial site in Kansas City. The location she chose was Union Cemetery, created in 1858 with the merger of two smaller and inconveniently located graveyards. The plot in Union Cemetery where Bingham was interred had been the tomb for Mattie's first husband, Johnston Lykins, a doctor and former mayor of Kansas City. As this photograph shows, Lykins's tombstone is in the background,

where it displays an edifying inscription, particularly for a deceased physician—"There shall be no more death." In the foreground stands the splendid monument commissioned by Mattie for George. It bears a medallion bust of the artist, naming him as "General Bingham," a reference to his service as adjutant general of Missouri, which had brought George a title that he seemed to enjoy. For herself, Mattie arranged to have a simple flat stone marking where she rested between the two distinguished men. Mattie Lykins Bingham died in September 1890 of cancer.

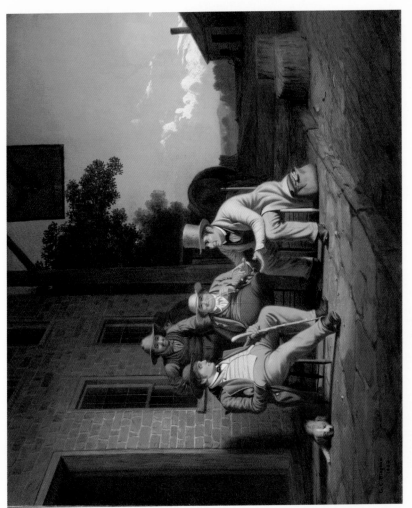

Canvassing for a Vote, 1851-1852

Nelson-Atkins Museum of Art, Kansas City, Mo. (purchase of Nelson Trust), 54-9, photo by Jamison Miller

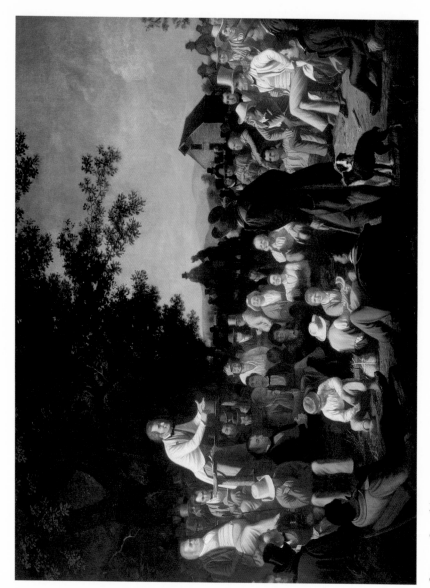

Stump Speaking
Saint Louis Art Museum, gift of Bank of America

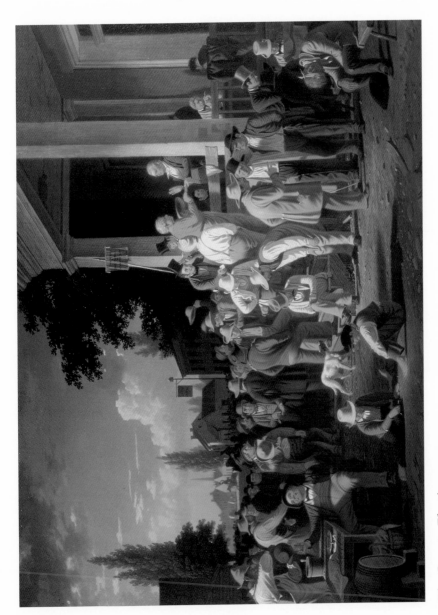

The County Election

Saint Louis Art Museum, gift of Bank of America

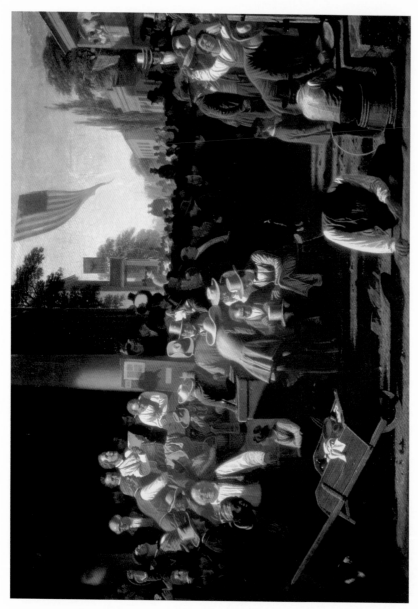

The Verdict of the People
Saint Louis Art Museum, gift of Bank of America

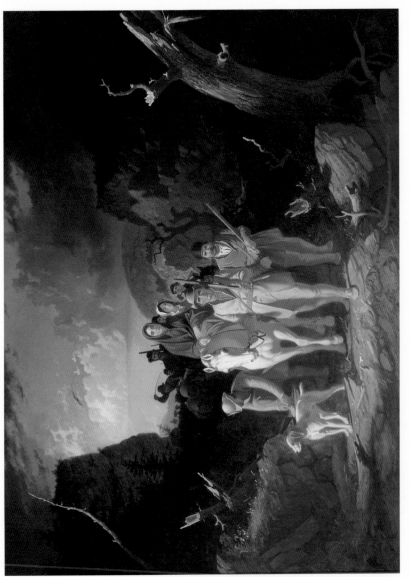

Daniel Boone Escorting Settlers through the Cumberland Gap, 1851–1852

Oil on canvas, 36 1/2 x 50 1/4, Mildred Lane Kemper Art Museum,
Washington University in St. Louis, gift of Nathaniel Phillips, 1890

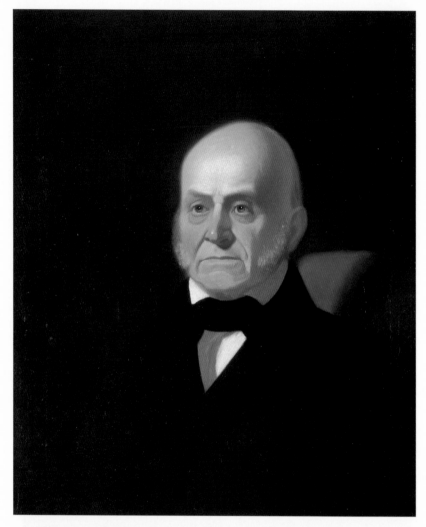

John Quincy Adams

National Portrait Gallery, Smithsonian Institution

Order No. 11

State Historical Society of Missouri, Columbia

Graves of George Caleb Bingham, Mattie Lykins Bingham, and Johnston Lykins

Photos by Thomas B. Hall III

past life, I think I will find much greater comfort than attends the discharge of the thankless duties of a public office. I now covet freedom and cheerful society." Ah, but it was still difficult for him. When George packed up to vacate the adjutant general's office, his determination to quit politics faltered just a bit. Perhaps, he mused to Rollins, the new governor, John S. Phelps, might invite him to remain in the office rather than award it to one of the new administration's "more intimate political friends." If Phelps were to do so, George acknowledged he would most likely "remain at my post here . . . but I feel no concern about it. I know that I will be much happier in devoting myself to art and enjoying the society of my friends, untrammeled by office."

Bingham did not, however, say farewell to statesmanship without expressing fulsomely his gratitude to James Rollins for his support and abounding kindness. "I shall never be able to repay you for a disinterested friendship such as few men have the good fortune to be blessed with on earth." But Rollins had not exhausted his capacity to help George. His final good deed was to see that George Caleb Bingham was appointed as the University of Missouri's first professor of art. The position was entirely an honor and carried no burdens. It was an assignment easily within Rollins's power to arrange as he was presiding officer of the university's board of curators.

This benefit overwhelmed George and brought forth further expressions of his gratitude. He assured Rollins: "No man could be blessed with a truer and more constant friend than I have ever found in yourself." Bingham readily conceded that their association invariably had been one in which all favors and help were given by Rollins, leaving George perpetually filled with thankfulness. Truly, said Bingham, Rollins had shown him always "the tenderest solicitude of a brother."

George's affection for James Rollins led to one of his finest portraits—of which only a photographic version remains today. Bingham painted the life-size picture of Rollins in 1873. The imposing subject was shown standing, and Bingham did full justice to Rollins with his lengthy black beard, worthy of a prophet.

He looked every bit the role ascribed to him by the public, "The father of the University of Missouri." The portrait was destroyed when the University of Missouri's Academic Hall burned in 1892.

Not even Rollins could console Bingham when sorrow overwhelmed him soon after he retired from office. The cause went far beyond his deepening illness and his disillusion with public life. On November 3, 1876, George's wife, Eliza Thomas Bingham, died in the Fulton State Hospital, which had been established in 1847. Her death was neither sudden nor surprising for her condition had darkened Bingham's letters to Rollins during the previous two years. But George could not bring himself to spell out the nature of the "illness" even to Rollins until a few days before Eliza's death. He then announced that her mental collapse had come from the shock of a medical diagnosis, a mistaken one as it turned out, that she suffered from a severe lung disease and that she must prepare to die.

The larger story appears more complicated. Never a strong person emotionally, Eliza was mentally ill by 1875. While diagnosis is now difficult, we do know that on October 22, 1876, she had lapsed so deeply into a state of delusion that a brokenhearted George reluctantly placed his wife in the Fulton institution. She was forty-seven and George was sixty-five. During the previous spring, when her symptoms were less severe, George retained enough hope to send her, in the company of their son, Rollins, to Philadelphia to see the great Centennial Celebration. Bingham believed that such a dramatic change might restore Eliza. After Philadelphia, mother and son were encouraged to visit Virginia, but there the benefit of travel was lost, and Eliza had to be brought back to Missouri.

Shortly before taking Eliza to the asylum in Fulton, George broke down and poured out his heart to James Rollins. "It has pleased God to visit me with an affliction which it will require all the fortitude which I can summon to my aid, to bear." As he described Eliza's condition, George took a degree of comfort from knowing that his wife's delusions kept her "inexpressibly

happy." Her "derangement" brought "brilliant visions of Heaven and her departed relatives and friends." According to George, Eliza was frequently visited by "her Savior," who "converses with her," instructing her in all things. Evidently, these divine directions led her to ask "impossible things of me . . . and my not performing them distresses her very much." Eliza began to cry that her husband no longer loved her. As a result, George acknowledged that "my presence frequently appears hurtful to my wife."

After her admission to the asylum, the examining staff advised George that it would be best if he did not see his wife for the time being. On October 31, 1876, writing from his "dark and dreary" world, George informed James Rollins that Eliza's condition had been pronounced "hopeless." In no pain, she was "peacefully traveling to the home of the blessed." Even now, said Bingham, his wife imagined herself already in Heaven "and speaks of herself no longer as a tenant of earth."

Only James Rollins was told of this rapid deterioration. George had kept the news even from his son Rollins, who was a student in the Kemper School in Boonville. Consequently, another favor from James Rollins was necessary. George asked that when Eliza died, Rollins should go to the Kemper School and break the news to Eliza's son and then accompany the lad to her funeral. "Ten thousand thanks," George wrote, adding that Eliza was to be interred beside her parents.

Four days later, Eliza Bingham died, although the actual cause of death is uncertain. While George was prepared for the event, the shock of his wife's death had a profound effect on him. Temporarily, he entered something resembling a spirit world where he was convinced that Eliza came to him, talked with him, and kissed him. He passed through a brief religious experience, leading him to urge James Rollins "to exhibit your faith in Christ by becoming a member of his visible church." George assured his friend that this step would bring strength even in political struggle. For with Christ as "our King and we obedient to his authority, traitors to his cause, however numerous, will not hurt us."

After a few unsteady months, George's natural resilience came to his rescue. It was not spurred by a yen for politics, although in one or two weaker moments he hinted to James Rollins that he could be receptive to holding another office. This inclination was brief, and George loudly renounced public life once again after political maneuvers deprived him of being named one of Missouri's representatives to the great Paris Exposition. When he discovered that neither of the two individuals chosen was an artist, Bingham was loud in his disgust. Surely, he grumbled, he had a powerful claim to an expense-paid stay in Paris in view of "my being an artist of long standing reputation and now professor of Art in the University of Missouri."

After being passed over for the honor Bingham announced to Rollins that he would no longer even seek support for major art projects. "In my present condition," he wrote in April 1877, "it suits me best to paint portraits chiefly, as in doing so I am more constantly brought into agreeable association with appreciative friends."

Among these comfortable acquaintances was a Kansas City widow, Mattie Lykins. Within five months after Eliza's death, Mattie became George's intimate companion and was the main cause of his recovery from grief. For many years, Mattie had been a close friend of both Eliza's and George's, as had been her late husband, Dr. Johnston Lykins, who had been a partner with Eliza's father in establishing the Baptist denomination in Jackson County. Lykins had a colorful career, including a brief stint as Kansas City's first mayor. He lost his wealth in the economic collapse during the 1870s and died while still in bankruptcy. Mattie had become the former mayor's second wife in 1851. He left her a widow a few weeks before the death of Eliza Bingham in November 1876.

Mattie Livingston Lykins was born in Kentucky in 1824. Her family could point to an ancestor who had signed the Declaration of Independence. She had strong southern sympathies, which made the area around Kansas City very appealing, and she moved to Lexington, Missouri, to become headmistress of a

girls school there. She brought an affiliation with Unitarianism, to which eventually she made George an adherent. During the Civil War she had greatly annoyed General Ewing by her emphatic southern allegiance so that when the infamous Order No. 11 was issued, Mattie briefly became a displaced person, forced to live away from the border area. When she returned to Kansas City, her personality had become even more aggressive.

Mattie's special interest was the care of orphans left by Confederate soldiers and their wives. This sympathy sometimes caused her difficulty in the Kansas City area, where wounds left by the war had not healed. One of those unwise enough to oppose Mattie's plans for a Confederate orphanage had been James Piper, who was married to Mary Thomas, Eliza's sister. George disliked him, calling Piper "my miserable brother-in-law." Mattie had gotten the best of Piper in a public exchange, leaving the hapless fellow resolved to get even, a determination redoubled when Piper discovered that George had speedily overcome his grief at Eliza's death and moved in with Mattie Lykins.

The Pipers sought vengeance against the sinning couple by attempting to disrupt the relationship between George and his son Rollins, who looked fondly upon Mary Piper as his aunt. The Pipers seized their chance to make trouble when, in February 1878, George departed for a stay of two months in Washington. This time he went as a private citizen to seek congressional approval of claims held by Kansas City citizens against the federal government for wartime damages to property. He also intended to paint portraits of the nation's leaders.

Before he left Kansas City, George believed his efforts to make his son an admirer of Mattie Lykins had succeeded. He was certain the boy would accept her gladly as a stepmother. The Pipers, however, soon dissuaded young Rollins from any such accommodation by regaling him with stories of Mattie's indiscreet ways, including the prediction that she would seize for herself any legacy the young man might anticipate from his father. Rollins Bingham responded by loudly repudiating his father, calling George "a foolish old man in his dotage."

When news of the Pipers' campaign reached George in Washington, it nearly unhinged him. He wrote daily letters to James Rollins begging for advice and help. The father acknowledged that he almost "idolized" his son, seeing in him great talent in many areas—talent that was apparent to few other observers. Indeed, a secondary reason for George's going to Washington had been to seek young Rollins Bingham's admission to the Naval Academy. He was unsuccessful in this, as he was in many other efforts to build a career for his son.

While George wept in Washington and spoke of suing the Pipers and of his fears that Rollins was now beyond a loving father's reach, Mattie Lykins and James Rollins came to the rescue. For her part, Mattie sent soothing letters to George calling him "my darling" and "my dear abused one," while James Rollins captured the attention of his young namesake by pointing out that George was about to cut off the young man's allowance. It was a clever stroke. The money was the sixteen-year-old lad's only source of income, and Rollins Bingham soon apologized to his father for heeding his Aunt Mary Piper's gossip about Mattie.

George returned from Washington in April 1878, haggard but much relieved. Then, after making a short trip to Texas to visit his daughter Clara and her children, he and Mattie put an end to gossip about them by being married on June 18, 1878. The couple promptly left for Colorado, where the bride hoped the bracing air and time to paint landscapes might help the groom overcome a return of the weakness in his lungs.

For a time, George's health appeared much improved, for which he gave full credit to Mattie and her "constant care and attention. . . . It seems to be her greatest pleasure to contribute to my happiness in every possible way." George confided in James Rollins that he hoped to live long enough so "that I may be able in some measure, to compensate her for the unselfish love which exhibits itself in her every act relating to myself." Even his son Rollins was "conducting himself very well, cheerful and obedient." The young man now aspired to become an attorney, an

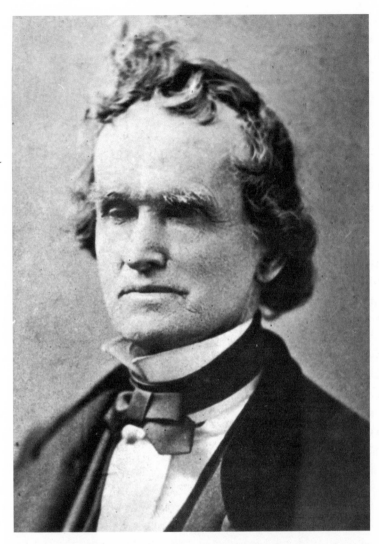

Bingham in old age (photo c. 1878). While Bingham painted several self-portraits during his last years, none seem to show the physical and emotional effect upon him of his difficult life. He lived to be sixty-eight, his last decade marred increasingly by ill-health. Always something of a romantic, Bingham claimed that his third marriage did wonders to restore him, but he died after barely a year of wedded bliss. *State Historical Society of Missouri, Columbia*

ambition that pleased George, who had never lost his own fondness for toying with the law.

In his newly married state, Bingham turned again to artistic endeavors and thrived momentarily. He established two studios, one in Kansas City and the other in Columbia, where Professor Bingham now appeared with some frequency—mainly, it seemed, to allow students to observe him at his easel. No salary accompanied the professorial appointment, but the hospitality provided by James Rollins and his family meant more to George than any financial reward. And, of course, there was always the line-up of individuals who clamored to sit for a portrait painted by the man known as "the Missouri artist." All this attention pleased George, and he readily waved off the renewed suggestions that he run for office, now coming particularly from the Greenback party. He contended that his recent success as an artist, particularly with "female portraits," demonstrated "that my skill rather increases than diminishes with increasing years."

But advancing age also emphasized George's physical ailments. He and Mattie managed to make a trip to Richmond, Virginia, in November 1878 where Bingham had been invited to serve as a judge in a competition offering a prize for the most desirable monument memorializing the late General Robert E. Lee. George took great delight in the fact that the Lee Monument Association had specifically asked Missouri's Governor Robert M. Yost to name him as Missouri's commissioner—when Yost had intended to appoint someone else. Furthermore, Bingham was convinced that this return to his native state "may be of some advantage to me professionally." He pledged that as a judge he would "close my eyes to every thing but merit."

Beyond looking after her spouse's welfare, Mattie accompanied George to Richmond to take up her own role, that of second cousin to Lee's great associate, the heroic General Stonewall Jackson. While Mattie was enjoying her prominence, the trip unfortunately came to an early end. No funds to pay for the monument had been raised. No models had been submitted, and the tribute to Robert E. Lee had to wait another ten years.

The trip to Virginia did nothing to improve George's health; his severe cough and frequent weariness actually worsened. To his embarrassment, when the time came for him to comply with the one requirement that the University of Missouri had attached to his appointment as professor of art—delivering a public lecture—George was too ill to read his address. With the artist confined to his bed in Kansas City, it was his great friend James Rollins who came to the rescue. On March 1, 1879, Rollins read Professor Bingham's remarks to an audience in Columbia.

The title of the lecture was "Art, the Ideal of Art, and the Utility of Art." George had complained that neither he nor most other artists were able to put into words their ideas about their profession. That was evident in the draft of the lecture Bingham sent to James Rollins—who found himself obliged to intone such lines from Professor Bingham as "Art is the outward expression of the esthetics sentiment produced in the mind by the contemplation of the grand and beautiful in nature, and it is the imitation in Art of that which creates this sentiment that constitutes its expression." At least George must be given credit for seeking to sound like a professor.

Later that spring, Bingham improved enough to be in Columbia for several weeks, visiting the Rollins family and painting portraits. He continued to grouse about the eternal delays in Jefferson City and Washington, D.C., in paying the claims that honest citizens—including George himself—had presented for damages to property during the Civil War. Those hostilities had been concluded fourteen years before. Bingham was also vexed at the Missouri legislature's refusal to accept his wife Mattie's offer of her orphans' institute—a building located at Thirty-second and Locust Streets in Kansas City—as a gift to the state. Even in his last hours, George was still frustrated by what he saw as the corruption endemic in the American body politic.

On July 5, 1879, James Rollins accompanied George to the railroad station in Columbia and bade him farewell as Bingham caught the train to Kansas City. Seemingly no more unwell than usual, George returned to Mattie and their residence in the

Lykins Institute, only to fall gravely ill. On July 7, a telegram arrived at the Rollins residence in Columbia bearing the news that George Caleb Bingham had died on that day. The cause of death was given as cholera morbus.

Each in his or her way, James Rollins and Mattie Lykins Bingham undertook to honor the memory of the departed Missouri artist. Rollins came to Kansas City for the memorial service, serving as speaker for the occasion. The *Kansas City Times* considered the ceremonies to have been remarkably impressive, particularly because of the moving eulogy given by James Rollins, "one of the most effective orators in the state." The paper reported that Rollins spoke with special power, as if "the presence of his dead friend before him seemed to touch his lips with inspiration." Perhaps somewhat ambiguously, the newspaper writer asserted that the service was "an event of a lifetime. It makes us think better of human nature, and teaches us that after all men are better than we think them." One wonders if the deceased artist and politician, so often convinced of the world's corruption, would have agreed.

As for the widow, Mattie Bingham carried on splendidly on behalf of her late husband. She arranged for his burial in Kansas City's Union Cemetery, placing his grave in the same plot where her first husband, Dr. Johnston Lykins, the former mayor and friend of Bingham's, rested. In 1881, with the advice of James Rollins, she commissioned a handsome monument to be placed at Bingham's grave. Today, though worn by time, the stone shaft stands at almost its original eleven feet in height and with its medallion bust of "General Bingham" still discernible.

The inscription for the monument, prepared by Mattie and approved by James Rollins, states: "Eminently gifted, almost unaided he won such distinction in his profession that he is known as the Missouri artist." Nary a word was added about the deceased's other role in Missouri, that of a politician who aspired to be what George had long deemed a rarity, an honest statesman.

Conclusion

In spite of James Rollins's stirring praise of his friend, and Mattie Bingham's creation of an imposing monument for her husband, Bingham—the artist and the statesman—was soon forgotten by Missouri and the nation. Rollins devoted his remaining days to encouraging education in Missouri, retiring in 1886 after nearly twenty years of service as president of the board of curators of the University of Missouri. When he died in January 1888, James Rollins had surely earned the title "Father of the University."

Mattie Bingham outlived Rollins by almost two years. Since George's death, she had been mostly occupied in caring for the orphaned children in her institute, and in advertising the canvases and engravings George had personally retained in his Kansas City studio. He had bequeathed this collection to Mattie, who kept it on display for several years at the Brunswick Hotel in Kansas City. When Mattie found she was suffering from terminal cancer, she demonstrated her continued devotion to the southern cause. Her will stipulated that her collection of Bingham works should be sold at auction for the benefit of the Confederate Soldiers Home in Higginsville, Missouri. One wonders what the artist, who had served briefly but proudly in the Union army and who had loathed the Confederate cause, would have thought of Mattie's decision.

In September 1890, Mattie Livingston Lykins Bingham died and was interred in Kansas City's Union Cemetery between the two husbands who awaited her. Eighteen months later, Mattie's collection of George's paintings and engravings was auctioned at the Findlay Art Rooms in Kansas City. The modest amount

paid for Bingham's work is shocking by today's prices. One of his versions of *Order No. 11*, which now hangs in the Cincinnati Art Museum, cost the winning bidder $675. The remaining canvases, mostly landscapes and figures, apparently brought $35 to $45 each. Thereafter, Bingham entered an oblivion that lasted forty years. What little recognition he received came from a few students of art history.

And then, with remarkable abruptness, George Caleb Bingham was restored to national esteem. First, there were triumphant exhibits of his work in 1934 and 1935, first at the Saint Louis Art Museum and then at the Metropolitan Museum and the Museum of Modern Art, both in New York City where Bingham had once craved attention. This recognition was then formally blessed thirty years later when, in praising Bingham's work, America's premier art critic, Hilton Kramer, caught the essence of George's greatness. Affirming that Bingham was "an immensely gifted artist," Kramer pointed out that the Missouri artist's achievement had been extraordinary. According to Kramer, Bingham had brought forth "something original—and at times, something exalted—out of the very deprivation of his situation."

Hilton Kramer had in mind the artistic limits in training and in surroundings that Bingham had overcome. While agreeing with the critic, some persons are tempted to marvel at what Bingham's career might have been. They deplore the two handicaps that seem to have kept him from growing in talent and in the amount of great work he might have produced—the first being his complex personality that led him to surrender many precious days to politics and public affairs, and the second being to live during years of tragedy in Missouri, a time of hideous warfare and of extreme controversy and corruption in public life. This was an era whose conditions repeatedly drew Bingham away from his calling as an artist. It was this time of tumult that had cut short Bingham's stay in Europe where he might have grown in sophistication.

Finally, the ultimate assessment of the life of this wonderfully talented person should recognize the irony of his career. While

Bingham is admired today for his superb work as a painter, another side of his life is forgotten. We ought to remember that he gave much of his energy to working to make Missouri a better place to live. While devoted to his creative career, he refused to ignore what he saw as the need to enlighten the public regarding the democratic process in America.

By striving to be both painter and politician, George Caleb Bingham may have deprived posterity of many memorable works of art. But he was thereby able to leave another legacy, one quite apart from his great paintings—although it can be sensed in his works *Stump Speaking* and *The Verdict of the People*. These canvases show a citizenry deeply interested in the issues of their time and in the persons who proposed answers to those issues. Such paintings by Bingham should remind us that our republic's greatest strength arises from a citizenry where private aspirations do not smother individuals' awareness of public responsibility.

This may ultimately be George Caleb Bingham's greatest achievement, if we but recognize it. His work and his career remind us of a day when Missourians gathered earnestly to listen and to debate the issues of their time. They went to the polls in great numbers. Bingham's superb political paintings should be revisited to help us recall the full extent of the artist's career and personality. Today, as the cost of sustaining a free society makes ever-greater demands on a mostly distracted or cynical citizenry, the life and work of George Caleb Bingham offer more beneficial instruction than ever. Yes, he was a great artist—and yet he was much more.

For More Reading

The literature about George Caleb Bingham is extensive. Most of it deals with his career as a painter. Among these books, perhaps the more valuable and enjoyable for the general reader are the following: First, there is a beautifully illustrated volume of essays by Michael Edward Shapiro and others, *George Caleb Bingham* (New York: Abrams, 1990). The most thorough biography is John Francis McDermott, *George Caleb Bingham, River Portraitist* (Norman: University of Oklahoma Press, 1959). An unusual and refreshing approach to the artist's broader career is Nancy Rash, *The Painting and Politics of George Caleb Bingham* (New Haven: Yale University Press, 1991). Still valuable, although massive, are two volumes by E. Maurice Bloch, *George Caleb Bingham, The Evolution of an Artist* (Berkeley: University of California Press, 1967) and *The Paintings of George Caleb Bingham: A Catalogue Raisonné* (Columbia: University of Missouri Press, 1986).

For readers who may wish to move more closely into the personality and life of Bingham, there is no better avenue than to read the artist's letters to his friend James S. Rollins. The great majority of these have been published in several issues of the *Missouri Historical Review*. See "Letters of George Caleb Bingham to James S. Rollins," edited by C. B. Rollins, *Missouri Historical Review* 32-33 (October 1937–July 1939).

Index

Note: George Caleb Bingham appears in subentries as GCB.

About the Author

ʹe Missourian, was formerly a profes-
lege dean, and a university vice pres-
ıthor of numerous books, several of
ɔ. He recently published *John Quincy
Adams: A Public Life, a Private Life* and *The Lees of Virginia:
Seven Generations of an American Family*, both of which
were History Book Club selections. He resides in Min-
neapolis, Minnesota.